STUDIO PORTRAIT PHOTOGRAPHY

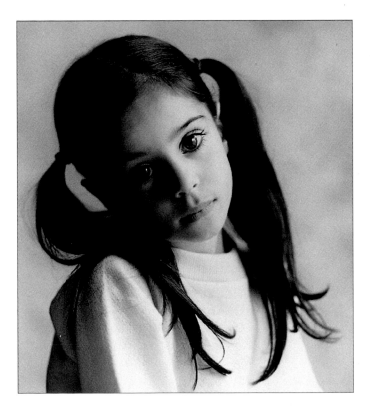

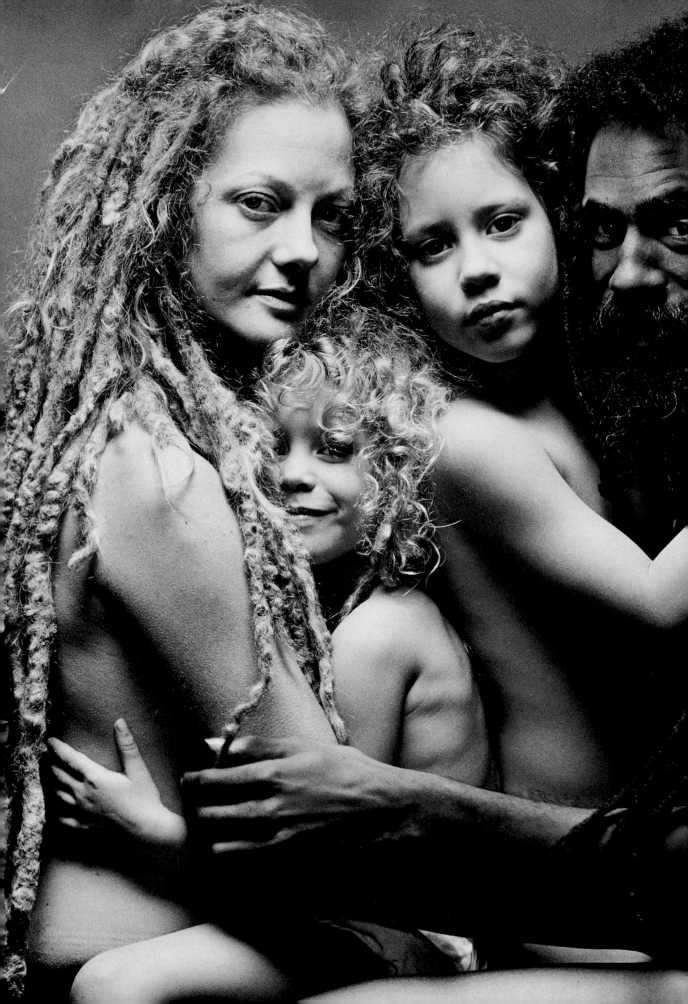

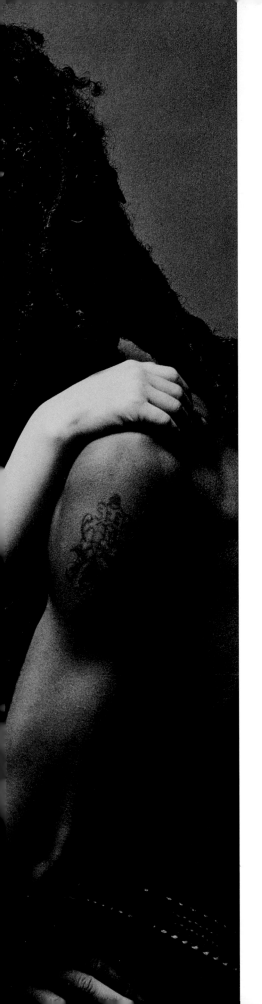

ROTOVISION
PRO-PHOTO SERIES

STUDIO PORTRAIT PHOTOGRAPHY

JONATHAN HILTON

A Rotovision Book

Published and distributed by RotoVision SA
Rue Du Bugnon 5
1299 Crans-Pres-Celigny
Switzerland

RotoVision SA, Sales & Production Office
Sheridan House 112/116A Western Road
HOVE BN3 IDD. England
Tel: 44-1273-7272-68
Fax: 44-1273-7272-69

Distributed to the trade in the United States:
Watson-Guptill Publications
1515 Broadway
New York, NY 10036

ISBN 2-88046-254-1

This book was designed, edited and produced by
Hilton & Kay
63 Greenham Road
London N10 1LN

Design by Phil Kay
Picture research by Anne-Marie Ehrlich

DTP in Great Britain by
Hilton & Kay
Printed in Singapore by Teck Wah Paper Products Ltd
Production and separation in Singapore by ProVision Pte Ltd
Tel: +65 334 7720
Fax: +65 334 7721

Photographic credits
Front cover: Linda Sole
Page 1: Gary Italiaander
Pages 2-3: Julian Deghy
Page 160: Julian Deghy
Back cover: Gary Italiaander

CONTENTS

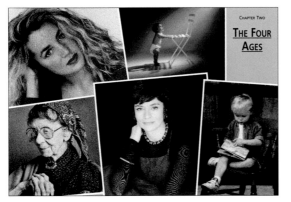

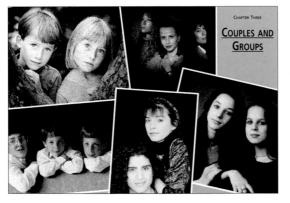

CONTENTS

CHAPTER FOUR SPECIAL EFFECTS

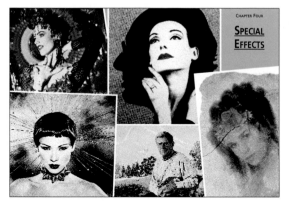

CHAPTER FIVE PORTFOLIOS

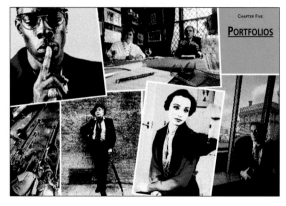

INTRODUCTION

The many, highly individual, approaches to, and treatments and interpretations of, the subject make portrait photography a rich and varied field of interest. The term *portrait photography* is indeed a broad one, encompassing everything from tightly cropped images of the face, or even just a part of a face, to full length portraits of subjects seen in a wide range of settings. The emphasis in this book is overwhelmingly on studio work, but this has been taken to include photographs shot not only in professional studios, but also more informal set-ups in the home and pictures taken in the workplace.

From the record that has come down to us through the efforts of artists living throughout all the ages of our history –

those involved in painting, drawing, or sculpture – it is clear that the representation of the human face has been an enduring theme. Even in the early days of photography – when lenses and photographic emulsions were so slow that exposure times of many minutes in bright sunlight were necessary to record any type of image at all – there were more photographs taken of people than of any other subject. The studios of our pioneering portrait photographers looked, at first glance, more like torture chambers. Seats were fitted with clamps to hold every part of the body rigid while the photographer stood, watch in hand, counting off the minutes, before slipping the dark slide home to protect the plate on which the light-sensitive

emulsion was coated. This, no doubt, accounts for the painfully stiff poses seen in photographs surviving from those days, as well as for the unrecognizably blurred faces of those who could not keep perfectly still in the embrace of those tortuous clamps.

Today, life is much easier for the portrait photographer, and for those in front of the lens as well. Modern films are thousands of times more sensitive than those first, primitive emulsions; lenses are engineered with such precision that there is virtually no distortion and only minimal light dispersal; and when supplementary illumination is needed for a photograph, then modern studio flash units deliver enough light in bursts as short as ¹⁄₁₀,₀₀₀ second, or even less.

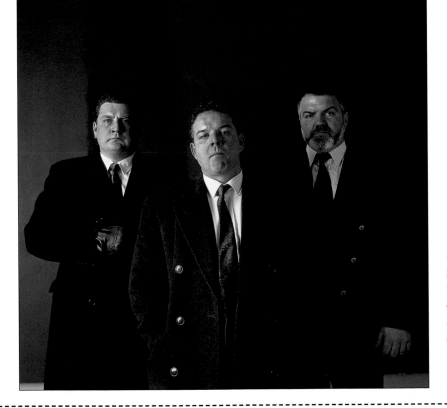

PHOTOGRAPHER:
Anthony Oliver

CAMERA:
6 x 6cm

LENS:
105mm

EXPOSURE:
¹⁄₆₀ second at f22

LIGHTING:
Studio flash x 2

◄ *Three nightclub doormen are the subjects for this group portrait, which is a part of a study commissioned by the National Portrait Gallery in London. The stark style of the studio lighting, using undiffused flash units, accentuates the sense of menace given off by the men.*

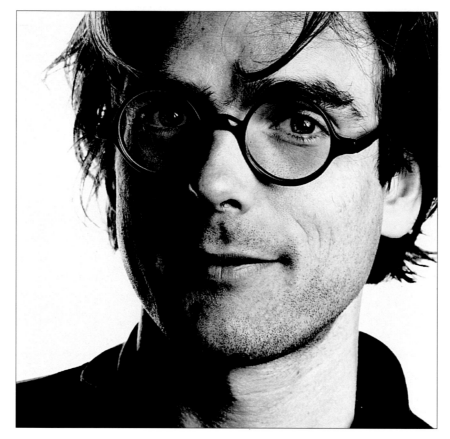

PHOTOGRAPHER:
Anthony Oliver
CAMERA:
6 x 6cm
LENS:
180mm
EXPOSURE:
¹⁄₂₅ second at f8
LIGHTING:
Studio flash x 2

◀ *By framing the subject in this fashion, the photographer has deliberately introduced the picture edges as part of the overall composition. The lighting, which has been set to give a contrasty, half-lit/half dark face, is relieved only by a little light spilling into the subject shadows from the background paper.*

About this book

The first chapter of this book deals with many of the issues that lie at the heart of good photography, irrespective of subject matter. Topics in Elements of Portraiture include the uses of shape and form as ways of adding to the information conveyed by a photograph and the different ways in which the frame can be employed to create interest, movement, and vitality in the photograph

One way of categorizing portraits is to divide them, broadly, into Four Ages (the second chapter of the book) – babies and toddlers, youth and young adulthood, maturity and middle age, and, finally, old age. It is fascinating to study the faces of the subjects in these different categories and see how the bland innocence of inexperience changes as the subjects mature and take on the features and characters that reflect their different lifestyles and histories.

Couples and Groups, the third chapter of the book, can represent a particular challenge to the portrait photographer. One of the key elements of successful group portraiture hinges on how the subjects are arranged within the space allowed them by the angle of view of the lens. Different group dynamics can be established by such things as eyeline, the placement of arms, or the tilt of the subjects' heads. Lighting, too, is often far more complicated to arrange when dealing with more than one subject.

Once you move into the world of Special Effects, the fourth chapter of the book, you begin to realize that the image produced by the camera, rather than being the end product, may be merely the starting point.

The final chapter, Portfolios, looks in detail at the pictures produced by two very different photographers. One is very much in the tradition of portrait photographers who see their work as a form of communication, a conversation between themselves and their subjects; in contrast, the other is a corporate portrait photographer, whose work is used by companies to create very specific impressions about the type of people they are and the organizations they represent.

EQUIPMENT AND ACCESSORIES

Predominantly, portrait photographers either work from a studio base – their own, one shared with other photographers, or one that can be readily hired – or in their clients' homes or workplaces. As a result, the camera format most often used by portrait photographers is one of the medium format types. These produce a larger negative (or positive slide image) than the other popular format – the 35mm camera. Generally speaking, the larger the original film image, the better the quality of the resulting print, since it requires less enlargement. The often relatively slow pace of a portrait session also seems to favour the use of the larger format, since it tends to encourage a more considered approach to each shot. However, good-quality 35mm SLR cameras and lenses are capable of producing superb results, and they come into their own when hand-held shooting is necessary, for "grabbed", candid-type shots, or when the session is perhaps unpredictable and the photographer needs to respond very quickly to the changing situation.

MEDIUM FORMAT CAMERAS

Traditionally the camera type most often used by portrait photographers is the medium format rollfilm camera. This camera format, of which there are many variations, is based on 120 (for colour or black and white) or 220 (mainly black and white) rollfilm. Colour film has a thicker emulsion than black and white, and so 220 colour film is not generally available because it cannot physically be accommodated in the film chamber of the camera.

◀ The smallest of the medium format cameras, producing rectangular negatives or slides measuring 6cm by 4.5cm.

◀ This is probably the best known of all the medium format cameras, producing square-shaped negatives or slides measuring 6cm by 6cm.

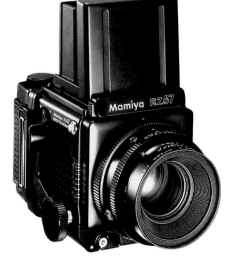

◀ This is the largest of the popular medium format cameras, producing rectangular negatives or slides measuring 6cm by 7cm. (A 6 x 9cm format is also available.)

The three most popular sizes of medium format cameras are 6 x 4.5cm, 6 x 6cm, and 6 x 7cm models. The number of exposure per roll of film you can typically expect from these three cameras are:

Camera type	120 rollfilm	220 rollfilm
6 x 4.5cm	15	30
6 x 6cm	12	24
6 x 7cm	10	20

The advantage most photographers see in using medium format cameras is that the large negative size – in relation to the 35mm format – produces excellent-quality prints, especially when big enlargements are called for, and that this fact alone outweighs any other consider-ations. The major disadvantages with this format are that, again in relation to the 35mm format, the cameras are heavy and slightly awkward to use, they are not highly automated (although this can often be a distinct advantage), they are expensive to buy, and you get fewer exposures per roll of film.

35MM SINGLE LENS REFLEX CAMERAS (SLRs)

Over the last few years, the standard of the best-quality lenses produced for the 35mm SLR has improved to the degree that for average-sized portrait enlarge-ments – of, say, 20 x 25cm (8 x 10in) – results are superb.

The 35mm format is the best sup-ported of all the formats, due largely to its popularity with amateur photogra-phers. There are at least six major 35mm manufacturers, each making an extensive range of camera bodies, lenses, dedicated flash units, and specialized as well as

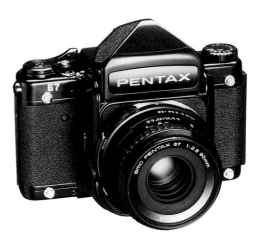

◀ This type of 6 x 7cm medium format camera looks like a scaled-up 35mm camera, and many photographers find the layout of its controls easier to use than the type on page 9.

more general accessories. Cameras within each range include fully manual and fully automatic models. Lenses and accessories made by independent companies are also available. Compared with medium format cameras, 35mm SLRs are lightweight, easy to use, generally feature a high degree of automation, and are extremely flexible working tools. For big enlarge-ments, however, medium format camera have an edge in terms of picture quality.

All 35mm SLRs use the same size of film cassette, of either 24 or 36 shots, in colour or black and white, positive or negative. Again because of this format's popularity, the range of films available is more extensive than for any other camera.

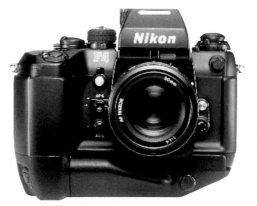

LENSES

When it comes to buying lenses you should not compromise on quality. No matter how good the camera body is, a poor-quality lens will take a poor-quality picture, and this will become all too apparent when enlargements are made. Always buy the very best you can afford.

One factor that adds to the cost of a lens is the widest maximum aperture it offers. Every time you change the aper-ture to the next smallest number – from f5.6 to f4, for example – you double the amount of light passing through the lens, which means you can shoot in progres-sively lower light levels without having to resort to flash. At very wide apertures,

◀ This top-quality professional 35mm camera, here fitted with a motor drive, features a rugged die-cast body; a choice of three different metering systems; interchangeable viewing screens and finders; exposure lock and exposure compensation; and a choice of aperture- or shutter-priority, fully automatic, or fully manual exposure.

however, the lens needs a high degree of optical precision to produce images with minimal distortion, especially toward the edges of the frame. Thus, lenses offering an aperture of f1.4 cost much more than lenses with a maximum aperture of f2.8.

At a "typical" portrait session, you may need lenses ranging from wide-angle (for showing the setting as well as the subject, or for large-group portraits) through to moderate telephoto (to allow you to concentrate on the face or head and shoulders of your subject). For 35mm cameras, the most useful lenses are a 28 or 35mm wide-angle, a 50mm standard, and about a 90 to 135mm telephoto.

As an alternative, you could consider using a combination of different zoom lenses. For example, you could have a 28-70mm zoom and another covering the range 70-210mm. In this way you have, in just two lenses, the extremes you are likely to use, plus all the intermediate settings you could possibly need to "fine-tune" subject framing and composition.

There is less choice of focal lengths for medium format cameras. They are also larger, heavier, and more expensive to buy, but the same lens categories apply – in other words, wide-angle, standard, and moderate telephoto. There is also a limited range of medium format zoom lenses to choose from.

▶ "Hammer-head" style acces-
sory flash units are capable of
producing high light levels and
so are often used with heavy-
duty battery packs. Always
choose a model with a tilt-and-
swivel head facility for a variety
of lighting effects.

ACCESSORY FLASH

The most convenient artificial light source for a portrait photographer working on location is undoubtedly an accessory flashgun. Different flash units produce a wide range of light outputs, so make sure that you have with you the one that is most suitable for the type of area you need to illuminate.

Tilt-and-swivel flash heads give you the option of bouncing light off any convenient wall or ceiling. In this way, your subject will be illuminated by reflected light, which produces a kinder, more flattering effect. You need to bear in mind, however, that some of the power of the flash will be dissipated as a result.

The spread of light leaving the flash head is not the same for all flash units. Most are suitable for the angle of view of moderate wide-angle, normal, and moderate telephoto lenses. However, if you are using a lens with a more extreme focal length, you may find the light coverage inadequate. Some flash units can be adjusted to suit the angle of view of a range of focal lengths, or adaptors can be fitted to alter the spread of light.

LONG-LIFE LIGHTING

One of the problems of using accessory flash is the number of times the flash will fire before the batteries are exhausted. There is also the problem of recycling speed – the time it takes for the batteries to build up sufficient power in order to fire once more. With ordinary batteries, after as few as 30 firings recycling time may be so long that you need to change batteries (the fresher the batteries, the faster the recycling time). This is not only expensive, it is also time consuming. The solution to these problems is to use a battery pack. With some types of pack, when fully charged you can expect as many as 4,500 firings and a flash recycling time as low as ¼ second – which is fast enough to use with a camera and motor drive. These figures do, of course, assume optimum conditions, such as photographing a nearby subject, with plenty of reflective surfaces nearby to return the light, and with the flashgun set to automatic.

Flash bracket

When you are using camera-mounted flash by preference, or when circumstances dictate, the type of flash bracket illustrated here could be a boon. By lifting the flash head well above the level of the lens, the possibility of "red-eye" is completely eliminated. This model is designed to accommodate 35mm SLRs as well as 6 x 4.5cm format cameras. It allows both camera types to be used either horizontally or vertically while ensuring that the flash remains centred directly above the lens. A front-mounted shutter release is also included for extra convenience. Different-model brackets are available for square-format cameras and for those with rotating backs.

▼ *This type of flash bracket neatly overcomes the major problem associated with camera-mounted accessory flash, red-eye, by lifting the lighting head well above the level of the lens.*

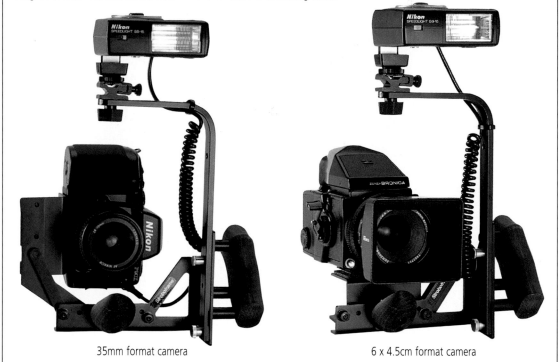

35mm format camera

6 x 4.5cm format camera

STUDIO FLASH

For the studio-based portrait photographer, the most widely used light source is studio flash. Working either directly from the mains or via a high-voltage power pack, recycling time is virtually instantaneous and there is no upper limit on the number of flashes.

A range of different lighting heads, filters, and attachments can be used to create virtually any lighting style or effect, and the colour temperature of the flash output matches that of daylight, so the two can be mixed in the same shot without any colour cast problems.

When more than one lighting head is being used, as long as one light is linked to the camera's shutter, synchronization cables can be eliminated by attaching slave units to the other lighting heads. Another advantage of flash is that it produces virtually no heat, which can be a significant problem when using studio tungsten lighting. To overcome the problem of predicting precisely where subject shadows and highlights will occur, which cannot be seen normally because the burst of light from the flash is so brief, each flash head should be fitted with a "modelling light". The output from these lights is low and won't affect exposure, but it is sufficient for you to see the overall effect with a good degree of accuracy.

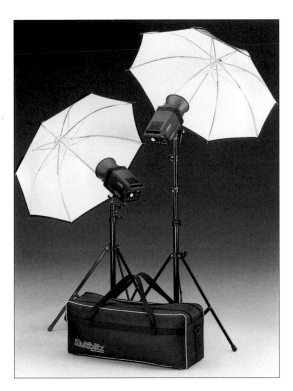

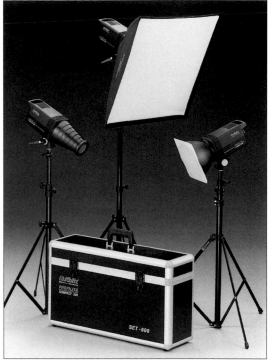

▲ Above left: *These modern studio flash units have been designed with location work in mind. This set-up, comprising two lighting heads, umbrellas, and lighting stands, packs away into the flexible carrying bag illustrated.*

▲ Above right: *For a wider range of lighting effects, this set-up has three lighting heads, with add-on softbox, snoot, and scrim, and three lighting stands. It all packs away into the case illustrated, which would easily fit into the boot or back seat of a car.*

▶ *Reflectors can be made out of pieces of cardboard – white for a neutral effect or coloured for more unusual results. But professional reflectors, made from materials with different reflective qualities, allow you a greater degree of control, either in the studio or out on location.*

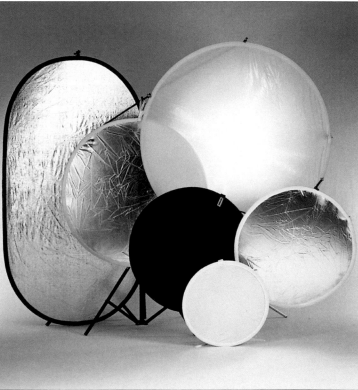

ELEMENTS OF PORTRAITURE

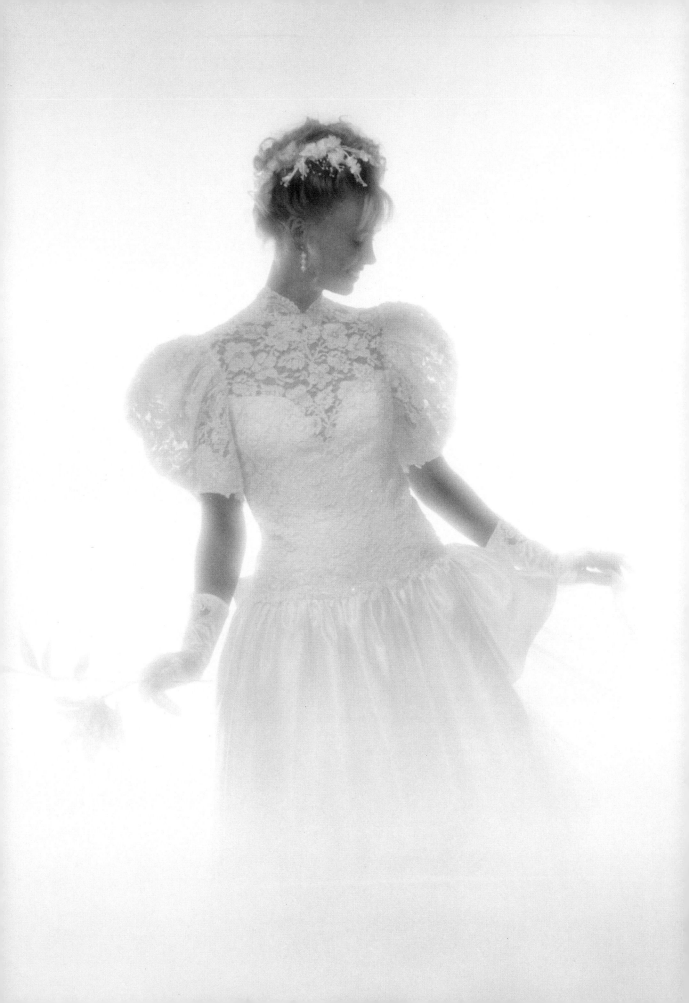

LIGHTING ATMOSPHERE

Studio portraiture is, by definition, more limited than location work in the type of backgrounds and settings that can be used. Thus, the atmosphere of a studio portrait is, largely, a function of the style of lighting adopted.

A "normal" subject is made up of a mixture of light and dark tones or colours, and an average exposure reading from a camera's built in metering system will endeavour to accommodate them all. However, by selectively metering, or using your camera's exposure-override facility, if available, you can alter the picture's lighting balance to conjure up the particular atmosphere you wish to create. Two broad terms used to describe very contrasting lighting styles are high-key and low-key.

A high-key photograph is composed predominantly of light tones or colours, while a low-key photograph concentrates on dark tones or colours. We all associate particular colours with certain moods and atmospheres. Yellows and reds, for example denote heat and passion, white is for purity, and blues and greens are considered cool, reserved colours. Likewise with tones: dark tones denote enclosed feelings, and can create images that are moody and perhaps even menacing. Light tones can produce images with an open, airy atmosphere; they seem candid, bright, and cheerful.

But not all the responsibility for the mood of a photograph rests on the lighting – the subject, too, must play his or her part. A vital part of the photographer's job conducting a portrait session is to pose the subjects in an appropriate fashion and to encourage them to use their facial expressions and their body language – the tilt of their head, the set of their shoulders, the tensing of muscles – to communicate with the camera and, through the camera, to the viewer of the photograph.

High key

To take a high-key portrait with an averaging exposure meter, first take the reading as you would normally and then set the camera controls to give about an extra stop's exposure – either open the aperture by one f stop (from f8 to f5.6, for example) or use the next slower shutter speed ($\frac{1}{25}$ second instead of $\frac{1}{50}$ second, for example). If you can take a selective exposure reading, perhaps by using a spot meter, fill the meter's sensor area with a darker-than-average colour or tone. This way, the meter will recommend, or set automatically, the aperture and shutter speed you require to produce a predominantly light-toned image.

PHOTOGRAPHER:
Jos Sprangers

CAMERA:
6 x 6cm

LENS:
80mm

EXPOSURE:
$\frac{1}{60}$ second at f11

LIGHTING:
**Studio flash x 4,
2 with softboxes**

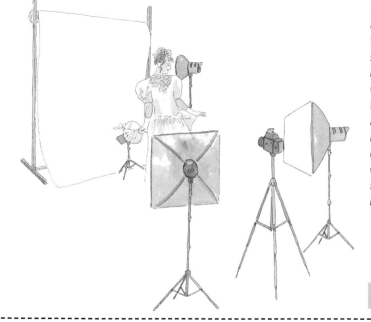

◀ To produce a high-key lighting effect, you want to flood the subject with light. In this set-up, two studio flash units, both fitted with softboxes, were positioned either side of the camera position to provide a wash of frontal illumination. In addition, a flash unit low down behind the subject provided rimlighting, while a fourth flash was directed at the background paper.

◀ Awash with light, this high-key portrait of a bride sends all the right signals of candour, openness, and purity.

PHOTOGRAPHER:
Gary Italiaander

CAMERA:
6 x 6cm

LENS:
120mm

EXPOSURE:
⅟₆₀ second at f8

LIGHTING:
Studio flash and barn-doors, plus reflector

Low key

To take a low-key portrait with an averaging exposure meter, first take the reading as you would normally and then set the camera controls to give about one stop less exposure – either close the aperture by about one f stop (from f5.6 to f8, for example) or use the next fastest shutter speed (⅟₂₅₀ second instead of ⅟₁₂₅ second, for example). If you can take a selective exposure reading, perhaps by using a spot meter, fill the meter's sensor area with a lighter-than-average colour or tone. This way, the meter will respond by recommending, or setting automatically, the aperture and shutter speed you require to produce a predominantly dark-toned image.

▶ *Directional lighting, confined to fall mainly on the sides of the faces of the subjects, dark clothes, and an underlit set combine to produce a pensive, moody double portrait.*

▲ *The lighting set-up for this low-key double portrait is extremely simple – a single studio flash unit fitted with a set of barndoors. Barndoors have individually adjustable flaps so that the spread of light from the flash can be carefully fine-tuned. The flash was placed on the left of the camera position so that its light fell on the sides of the subjects' faces furthest from the camera. A small reflector, mounted on a stand at eye level, was placed to the right of the camera to give a little extra detail in the shadow areas.*

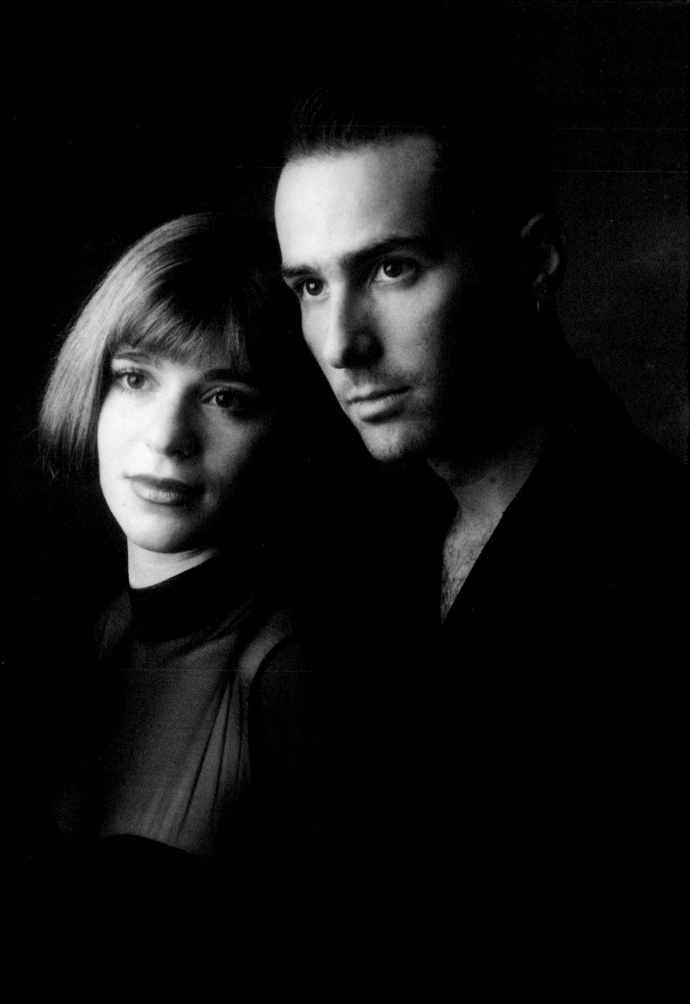

USING THE FRAME

Using the term "photographic composition" can be problematic, since it brings to mind a set of rules that should be followed in order to achieve a satisfactory result. In fact, there are no photographic rules that cannot be broken. However, by being aware of how the arrangement of visual elements within the frame communicates different things, you will be in a better position to manipulate the audience's response to your work.

At its most basic, composition is simply the position of the subject, and any other elements making up the image, in a visually pleasing fashion within the area bounded by the viewfinder frame. A centrally placed subject tends to imply a lack of movement within the frame and it is the most static of arrangements. Positioning your subject toward one side of the frame, or more toward the top or bottom, immediately introduces a sense of movement and perhaps tension as well. And the use of diagonal lines, as opposed to vertical or horizontal ones, is another way of introducing tension and apparent movement.

Colour can be another compositional device. "Warm" colours – reds, yellows, oranges – tend to advance in the frame toward the viewer, while "cool" colours – blues, greens – tend to recede. In some circumstances, therefore, the impact on the overall composition of different subject elements can be altered through the use of colour. Colour, too, can affect our perception of the amount of space subject elements (objects or people) occupy within the frame, with some colours making them seem larger or smaller. This also applies to the tones of black and white, with dark tones seeming to occupy more space than light tones, for example.

▲ *When the subject is shown in profile like this (above left), include more free space in front of the face than behind it. This avoids producing an image that looks uncomfortably cramped. This is especially important here* *because the face is so tightly cropped at the top. To gain some impression of how the shot would have looked if his face had been more centrally framed, see the comparative illustration (above right).*

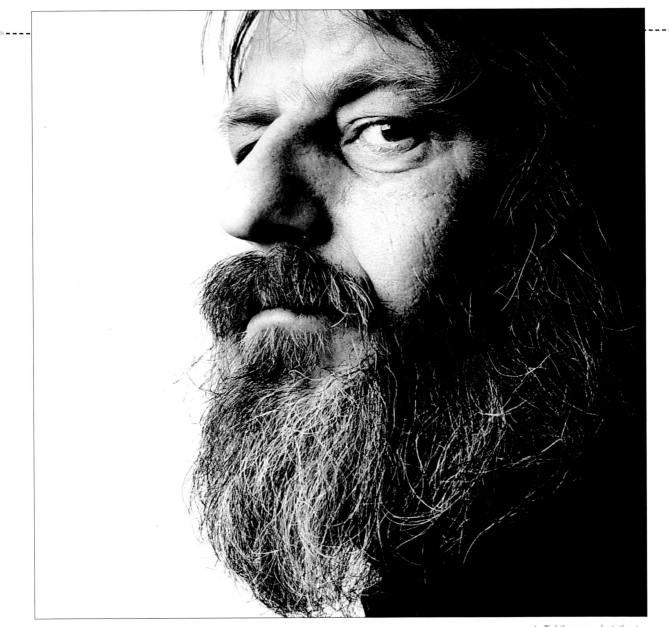

PHOTOGRAPHER:
Anthony Oliver

CAMERA:
6 x 6cm

LENS:
180mm

EXPOSURE:
¹⁄₁₂₅ second at f11

LIGHTING:
Daylight and studio flash

▲ *Tightly cropped at the top and side of the frame, this portrait shows a face full of character. Only one of the subject's eyes can be seen, and it is looking directly at the lens and, through it, at you.*

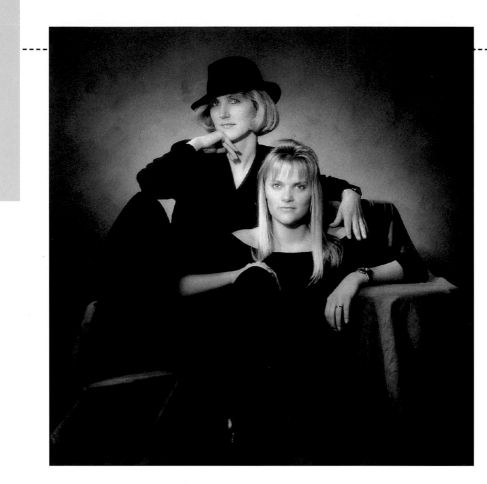

◀ The use of tone and shape in this double portrait gives the subject a solid, physical presence in the frame.

PHOTOGRAPHER:
Jos Sprangers
CAMERA:
6 x 4.5cm
LENS:
80mm
EXPOSURE:
⅒ second at f22
LIGHTING:
Studio flash x 3, 1 with softbox

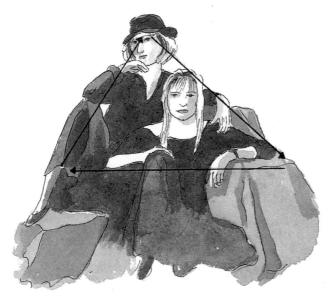

◀ Triangular shapes always tend to produce a very stable, solid-looking composition. This factor has been reinforced in this portrait by the dark clothing worn by the subjects and the deliberate underlighting toward the bottom of the frame, which add to the pictorial "weight" of the subjects.

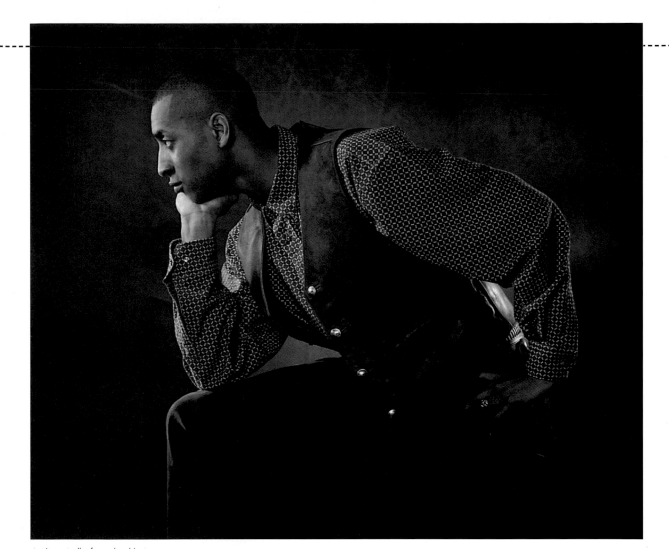

▲ A centrally framed subject usually produces a very static composition. Here, however, the photographer has directed the subject to adopt a pose that counteracts that "rule".

▶ The strongly diagonal lines formed by the subject's pose and posture, as well as his eye-line, which takes you out of the frame, produce a portrait full of movement and tension.

PHOTOGRAPHER:
Jos Sprangers

CAMERA:
6 x 6cm

LENS:
80mm

EXPOSURE:
⅟₃₀ second at f22

LIGHTING:
**Studio flash x 3,
1 with softbox**

PHOTOGRAPHER:
Jos Sprangers

CAMERA:
6 x 6cm

LENS:
100mm

EXPOSURE:
⅛₂₅ second at f8

LIGHTING:
**Studio flash x 2,
1 with softbox**

▶ *This picture breaks some of the "rules" of portrait composition – the subject's face is largely obscured and the subject's eyes are not engaging those of the viewer. But rules are meant to be broken, and it is an endearing and entertaining portrait nevertheless.*

▲ *One of the more useful rules of composition is known as the intersection of thirds. If you imagine that the frame produced by the viewfinder is divided both horizontally and vertically into thirds, then any subject element positioned on one of those lines is given additional emphasis. Particular emphasis is given to anything positioned on an intersection of lines, such as the child's eye in this portrait.*

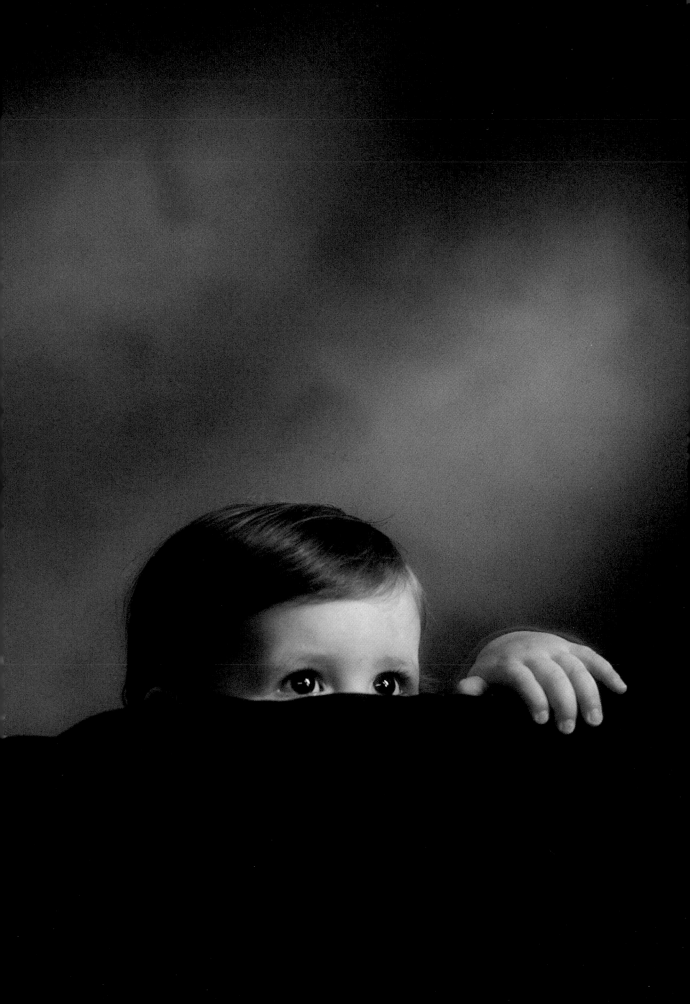

EMPHASIZING TEXTURE

The appearance of texture in photographs is the visual impression of what the surface being photographed would feel like if you could somehow reach into the frame and actually touch it. The importance of texture lies, therefore, in its ability to lift the image away from the flat two-dimensional paper on which it is printed and to give it a sense of realism.

Texture is most apparent when the light reaching the subject is directional, coming from the side and raking across the surface. Frontal lighting tends to have a texture-suppressing effect – something to bear in mind when you are trying to minimize the appearance of texture in, say, the clothing or skin of your subject.

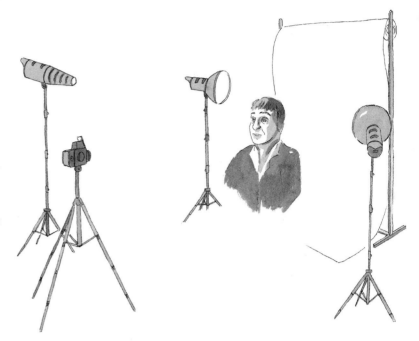

▲ The lighting for this studio portrait is hard and uncompromising. The face has been lit with a single studio flash unit to the left of the camera position and three-quarters on to the subject. The addition of a snoot to the front of the light narrows and concentrates the flash's output, ensuring that there is no unwanted spill-over of illumination into other parts of the face. Behind the subject, out of sight of the camera, two flash units have been directed at the plain background paper to kill any shadows thrown behind the subject and to ensure that he is seen against a toneless area of white.

PHOTOGRAPHER:
Anthony Oliver

CAMERA:
6 x 6cm

LENS:
120mm

EXPOSURE:
⅛₀ second at f16

LIGHTING:
Studio flash x 3

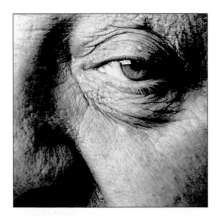

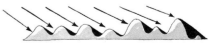

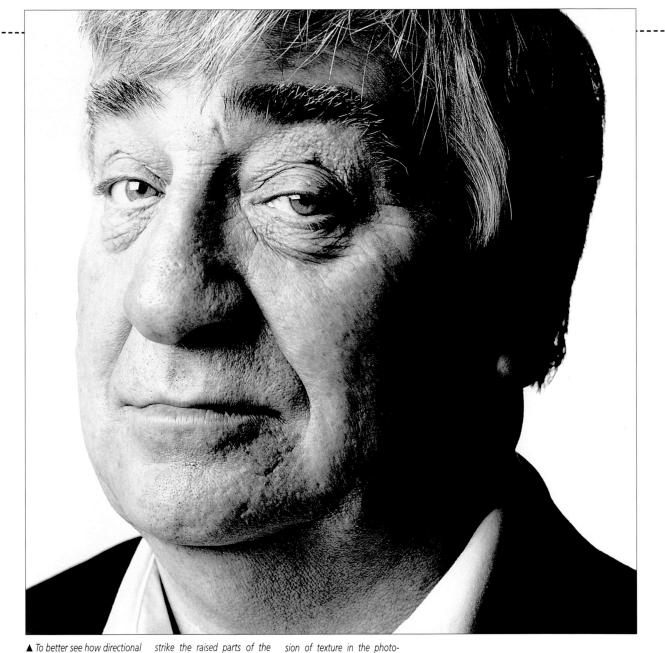

▲ To better see how directional lighting enhances surface texture, a small area of the subject's face has been reproduced here as an isolated and enlarged detail (far left). In the diagrammatic representation (left) you can readily see that directional lighting tends to strike the raised parts of the surface, creating a series of minute areas of highlighting. At the same time, each raised area casts a tiny shadow into its adjacent dip or hollow.

It is the contrast between these highlights and shadows that produces the visual impression of texture in the photographic image. If the lighting for this portrait had been more frontally arranged, then both the "peaks" and the "valleys" would have been equally illuminated, and the lit surface would have appeared relatively flat, and certainly less interesting.

PHOTOGRAPHER:
Mark Gerson

CAMERA:
6 x 6cm

LENS:
135mm

EXPOSURE:
⅟₃₀ second at f8

LIGHTING:
**Daylight and tungsten
photoflood**

EFFECTS:
**Negative printed through
texture screen**

▶ *Sometimes, the camera image is merely the first step in the picture process. In this shot of the Irish novelist and playwright Edna O'Brien, texture has been added to a "straight" portrait by printing it through a specially prepared screen. Texture screens can be bought ready made in a range of patterns, but it is relatively simply to make a screen to suit your specific requirements.*

MAKING AND USING A TEXTURE SCREEN

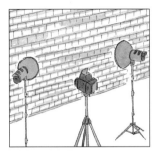

Find the appropriate surface pattern or area of texture to photograph that will become your texture screen. Move in close to fill the viewfinder frame with it, and then produce a series of negatives that are about two to three stops underexposed.

Process the negative, but underdevelop it by about 25-35 per cent. Vary the camera exposure and development time of the screen image as necessary until you have a negative of the right density.

Once this very thin negative is fully processed and dried, place it in the negative carrier of the enlarge, emulsion to emulsion with the negative of the portrait you have taken and expose them both together onto the same piece of printing paper.

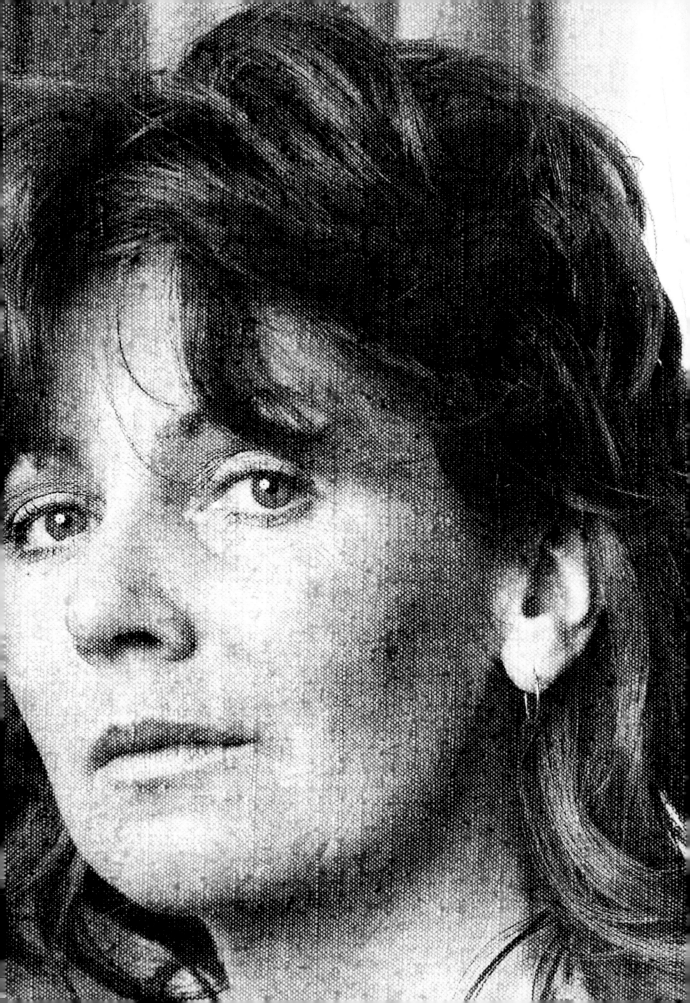

ACCENTUATING FORM

Whereas the appearance of texture in photographs depends on the often sharp contrast between lit and unlit subject planes, or surfaces, form is better described by the graduation of light and shadow as they merge and blend together to produce a sense of roundness and solidity. It is the visual impression of a subject's form that helps to give the photographic image its three-dimensional quality.

If form is an important element in the portrait you have in mind to shoot, then you need to pay particular attention to how you set the lights. Using studio or hand-held flash may sometimes be a disadvantage here. The burst of light from flash is virtually instantaneous and, thus, it can be difficult to judge precisely how the light and shade is falling on your subject until you see the processed results. Unless you are very experienced with flash, you may find continuous-output tungsten lighting and/or daylight easier sources to work with.

PHOTOGRAPHER:
Nigel Harper

CAMERA:
6 x 7cm

LENS:
180mm

EXPOSURE:
$\frac{1}{125}$ second at f5.6

LIGHTING:
Diffused daylight, photoflood, and reflector

EFFECTS:
Chemical toning

▲ The principal light source for this photograph was window light, diffused by net curtaining slightly to the left and behind the camera position. A photoflood next to the camera provided more frontal lighting, and a reflector, low down to the right of the camera, returned enough light to ensure the baby's downturned face was not lost in shadow.

▶ The soft roundness and solidity of this joint portrait of a mother and her young baby are the result of diffused daylight supplemented by light from a photoflood. Although neither is making eye contact with the other, the relaxed way in which the baby's head rests against her mother's cheek makes evident the bond of affection between them.

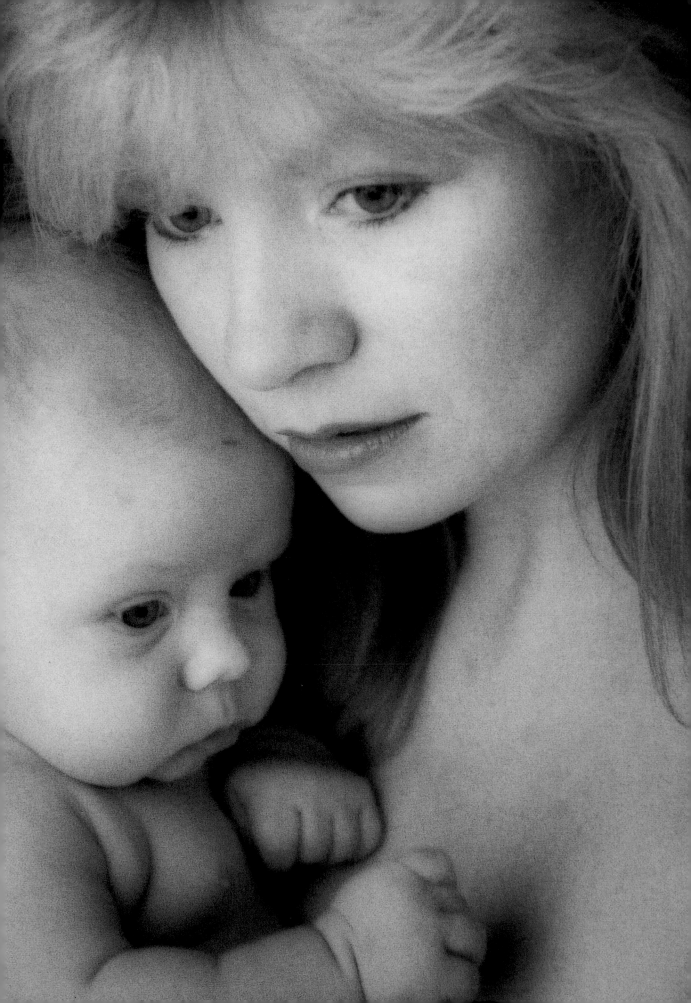

Hints and tips

● Studio flash may be fitted with low-power tungsten modelling lights that allow you to preview the fall of light and shadow and make adjustments before firing the flash.

● When judging the effect of lighting used to define form, make sure you view the subject from the picture-taking position. How the subject is lit is only relevant from the camera position.

▶ *In this portrait, the use of form to imply the dimension of depth can be seen to best advantage in the subject's hat face, and hands, as well as in the tangible roundness of the tulips resting on the table in front of her.*

PHOTOGRAPHER:
Nigel Harper

CAMERA:
6 x 7cm

LENS:
100mm

EXPOSURE:
⅟₃₀ second at f4

LIGHTING:
Spotlight, photoflood, and reflector

EFFECTS:
Chemical toning

▼ *Lighting here is principally from the left of the camera. A tungsten spotlight, used well back from the subject, creates the highlight on her cheek, while a photoflood, fitted with* *a scrim to soften its effects, was placed about half that distance away. To the right of the camera, a reflector on a lighting stand returns some light to that side of the subject's face.*

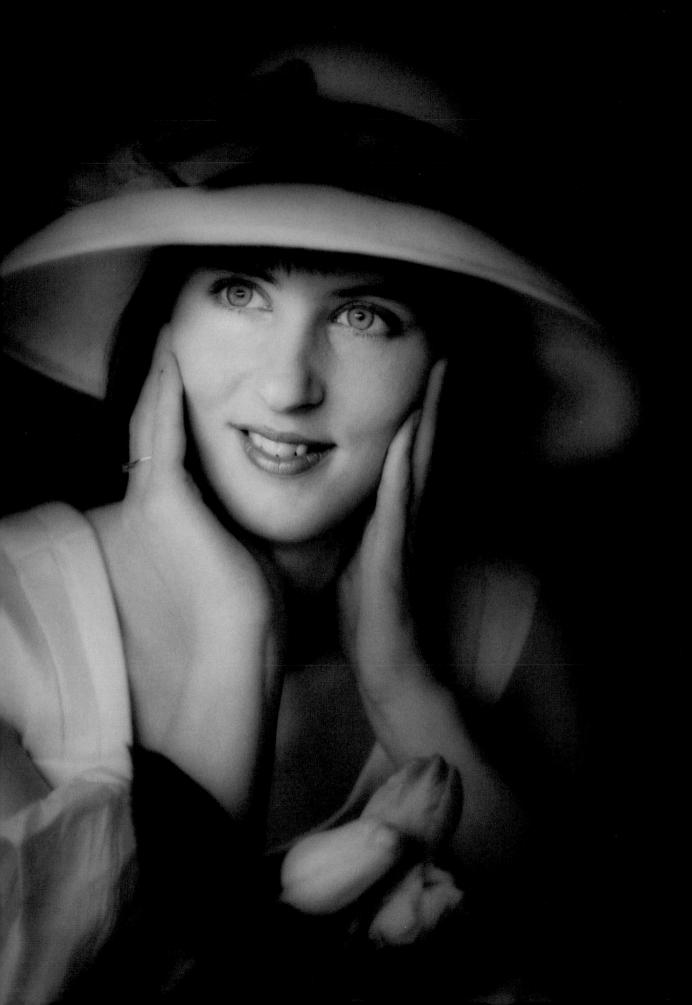

*U*TILIZING SHAPE

Of all the picture components, shape is probably the most fundamental. It does not, for example, rely on the surface characteristics of the subject, as does texture, or imply its solidity, as does form.

Shape is one of the pictorial devices used by photographers to create divisions and compartments within the frame, to add interest to the composition, and to guide the viewer's eye around the picture's content. Shape can be defined within the subject itself – by bone structure, for example, or by the fall of a person's hair or by clothing – or it can be external to the subject, yet still remain a key element of the overall composition.

PHOTOGRAPHER:
Nicholas Sinclair

CAMERA:
6 x 6cm

LENS:
150mm with 8mm extension tube

EXPOSURE:
⅟₆₀ second at f5.6

LIGHTING:
Studio flash with softbox and reflectors

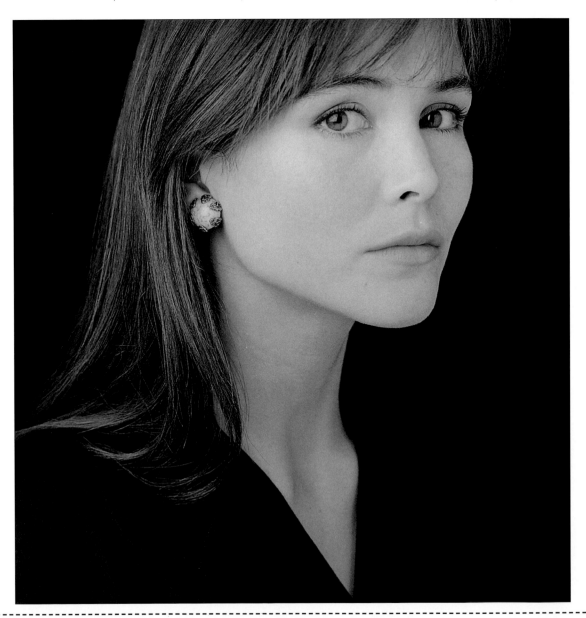

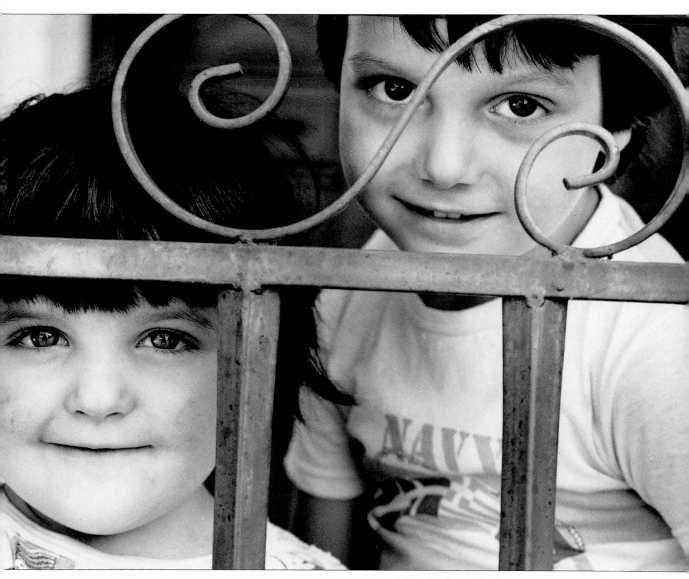

◄ The use of shape here is subtle but telling. The lighting emphasizes the bone structure of the woman's face, which stands out against a featureless background. The photographer has also used the picture edges, cropping in to the top of her head to emphasize the shape of the frame in which she appears. Finally, the eye is drawn to the V-shape of her neckline, which takes your attention downward, where it is brought to a halt by the bottom of the picture frame.

Hints and tips

● To reduce a subject to pure shape, without texture or form, arrange the lighting to produce a silhouette. The stronger the contrast between highlight and shadow areas, the stronger the potential silhouette will be.

● The strongly rectangular or square shape of the picture frame can become a part of the photograph's composition.

▲ Here the photographer has used the picture edges to restrict and confine his young subjects, producing an almost claustrophobic effect. Shapes within the composition, formed by the straight and curved sections of the wrought-iron gate, act as individual spaces in which the subjects have been carefully aligned.

PHOTOGRAPHER:
Nigel Harper

CAMERA:
35mm

LENS:
50mm

EXPOSURE:
½₅₀ second at f4

LIGHTING:
Daylight only

SPECIAL OCCASIONS

M ost commercial portrait photographers depend heavily on being commissioned to take "special occasions" pictures. When children are young, for example, they change physically very dramatically from year to year, and parents may have an annual portrait taken on or near their birthdays. Graduations, confirmations, bar mitzvahs, and anniversaries are all important events, but the occasion that brings in most revenue is without doubt wedding photography. Indeed, some commercial studios specialize in little else, and a good set of studio portraits before the wedding day will almost certainly lead on to a commission to cover the ceremony and perhaps the reception, too.

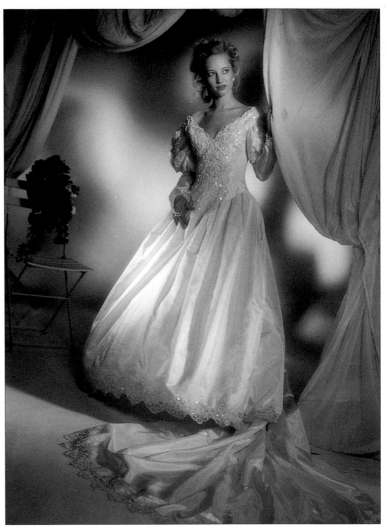

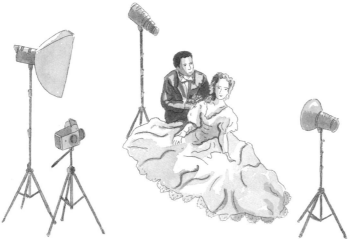

◀ After settling the bride and groom in position and arranging the woman's gown, the principal lights were set up to the right of the camera and higher up on the left. Using a snoot ensures that the beam of light falls only in a restricted area. Further back, another flash, with a softbox attached, was used to throw a dappled shadow on the rear wall. You can cut out and tape any pattern to the front of a softbox for this type of shadow effect.

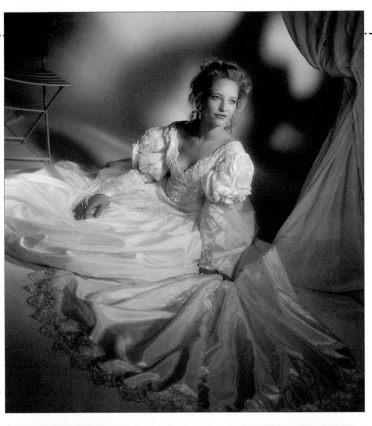

◀ ▶ *The most elaborate piece of wedding finery is undoubtedly the bridal gown. Much care, attention, and money are lavished on these creations and they need to be carefully arranged and precisely lit to show them and, of course, those wearing them, to the best possible advantage.*

PHOTOGRAPHER:
Jos Sprangers

CAMERA:
6 x 6cm

LENSES:
50mm and 80mm

EXPOSURE:
⅟₃₀ second at f16

LIGHTING:
**Studio flash x 3,
1 with snoot and
1 with softbox**

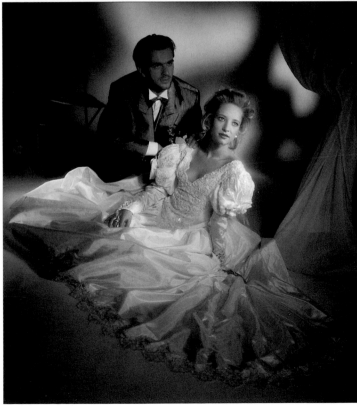

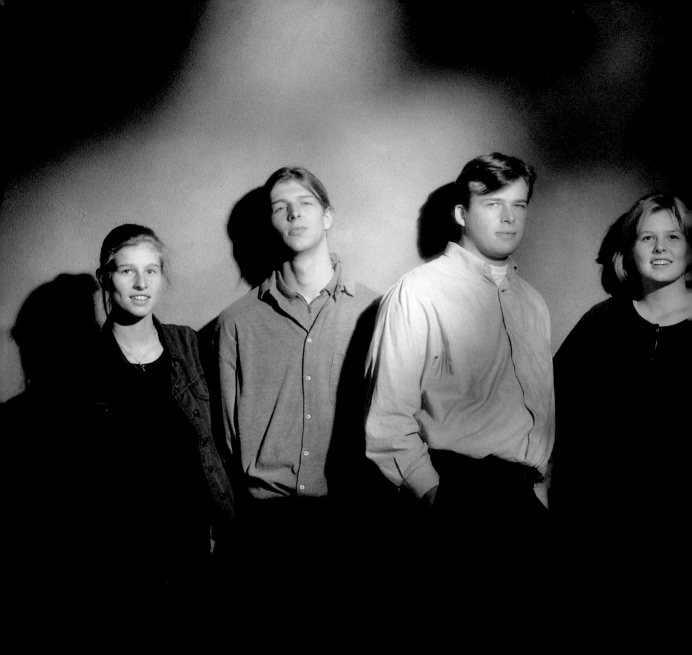

▲ High school graduation was the occasion that prompted this group portrait. These teenagers had a firm idea about how they wanted to be photographed, and so the photographer arranged a simple lighting scheme to match the mood created by their informal poses.

◄ Just a single studio flash was used to light this group. It was positioned to the right of the camera, set at an angle that sent light raking across the subjects, which accounts for the steadily lengthening shadows as you move down the line-up of figures.

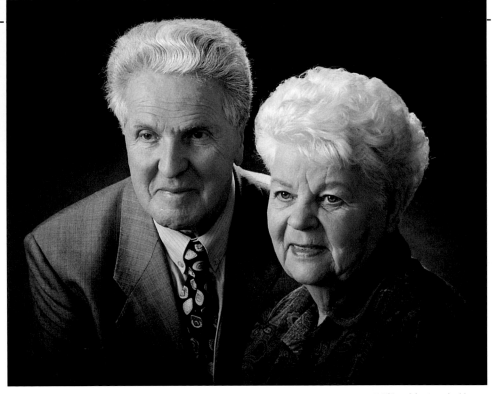

▲ This celebratory double portrait marks this couple's 40th wedding anniversary. The lighting was kept as frontal as possible to minimize the appearance of creases and wrinkles on the skin.

PHOTOGRAPHER:
Jos Sprangers

CAMERA:
6 x 4.5cm

LENS:
80mm

EXPOSURE:
⅛₂₅ second at f16

LIGHTING:
Studio flash

▲ The principal light used for this portrait was a studio flash with a snoot attached to throw a tightly controlled beam of light. The light was set to the left of the camera, while a reflector to the right ensured that contrast on the subjects' faces was kept to a minimum. Behind the subjects, another flash was used to light the background paper.

PHOTOGRAPHER:
Math Maas

CAMERA:
6 x 7cm

LENS:
100mm

EXPOSURE:
⅟₆₀ second at f16

LIGHTING:
Studio flash x2, 1 with snoot, and reflector

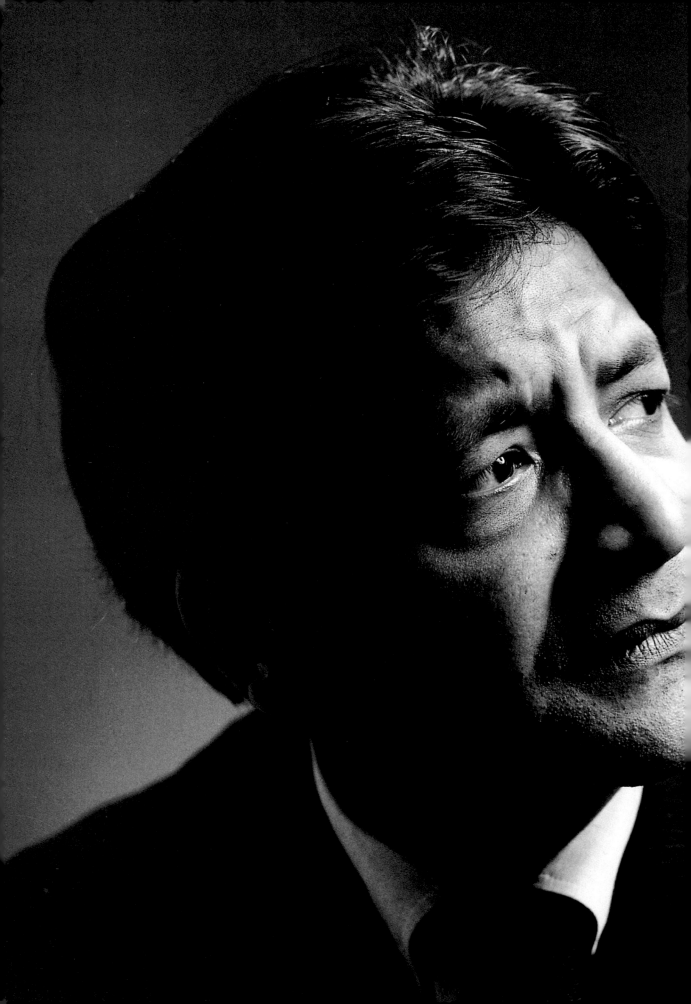

Working to a Brief

The potential of photography to communicate with a target audience is a potent force, so much so that photographers can sometimes be given a tightly detailed brief by clients specifying precisely the type of image they want produced. Actors, politicians, artists, business leaders, authors, musicians, models, and others in many different walks of life make use of photography to ensure that they are instantly recognized by particular groups of people.

PHOTOGRAPHER:
Mark Gerson
CAMERA:
6 x 6cm
LENS:
135mm
EXPOSURE:
½₀ second at f8
LIGHTING:
Tungsten floodlight and 2 tungsten spotlights

▲ The main light for this portrait was a 500w tungsten floodlight positioned to light principally the far side of the subject's face. Another light, a tightly focused spotlight, was used to create the highlight on his hair, while a third light was positioned behind the subject to create the graduated tone on the background paper.

◄ This formal portrait of the Trinidadian novelist Vidiadhar Surajprasad Naipaul was commissioned by the National Book League in the UK. The organization wanted a dramatically lit portrait of the author to use as a publicity poster.

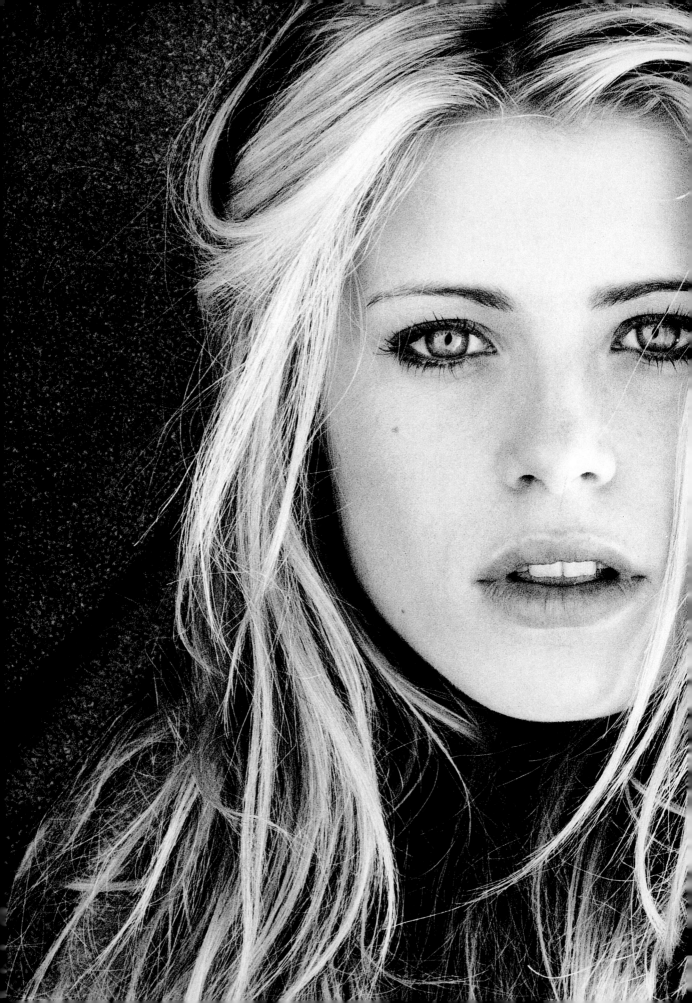

◀ Models have a constant need for new and imaginative portraits to keep their portfolios fresh and up to date. Agencies frequently commission new material of the models on their books for submission to picture editors, advertising agencies, and casting agents.

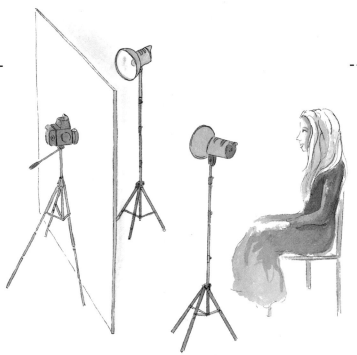

PHOTOGRAPHER:
Richard Braine

CAMERA:
6 x 6cm

LENS:
180mm

EXPOSURE:
⅟₅₀₀ second at f5.6

LIGHTING:
Studio flash

▲ To produce the even, virtually shadowless lighting used for the subject of this portrait photograph, studio flash was bounced off a large white paper screen. Within the area of the screen, a hole was cut to accommodate the camera lens.

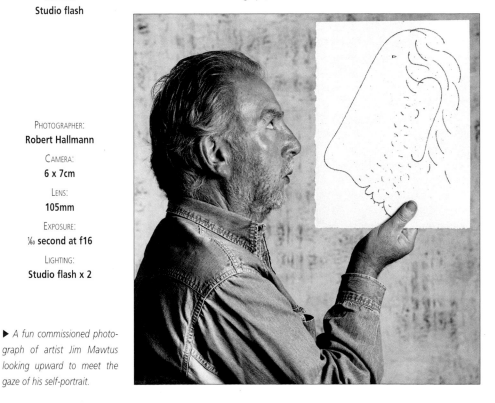

PHOTOGRAPHER:
Robert Hallmann

CAMERA:
6 x 7cm

LENS:
105mm

EXPOSURE:
⅟₆₀ second at f16

LIGHTING:
Studio flash x 2

▶ A fun commissioned photograph of artist Jim Mawtus looking upward to meet the gaze of his self-portrait.

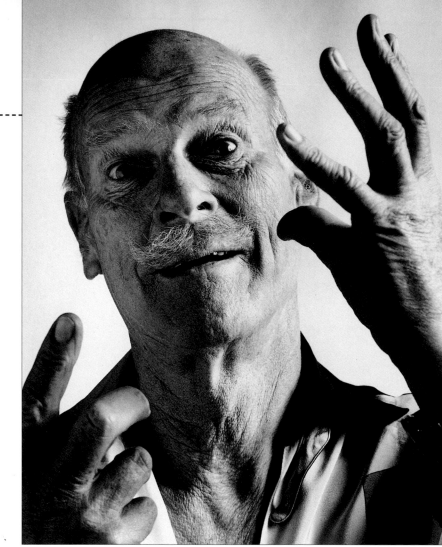

▶ A high-contrast, dramatically lit portrait such as this could be ideally used as a poster or record sleeve. The large area of dense black could be used to carry a lot of editorial information, reversed out as white type. A light reading was taken from the subject's face and the tungsten studio lights balanced so that one exposure would suit the subject's face, hands, and saxophone while leaving the rest of the set, and his dark-coloured clothing, massively underexposed.

PHOTOGRAPHER:
Anthony Oliver

CAMERA:
8 x 10in

LENS:
180mm

EXPOSURE:
½₅₀ second at f16

LIGHTING:
Tungsten spotlights x 3

▲ The flamboyant and effervescent personality of the fashion and portrait photographer Norman Parkinson shows through magically in this studio portrait. His hands, which punctuated the air whenever he spoke, act as frames, not only confining his face within the picture area but also contrasting in tone with the brightly lit background. A low camera angle helps to enhance the subject's stature.

PHOTOGRAPHER:
Trevor Leighton

CAMERA:
6 x 7cm

LENS:
50mm

EXPOSURE:
½₅₀ second at f4

LIGHTING:
Studio flash x 2

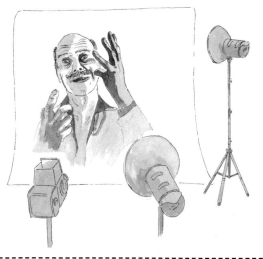

◀ Direct flash used low down creates a theatrical lighting scheme, not unlike that of the footlights at the front of a stage. Behind the subject, out of sight of the camera, another flash has been used to light the backdrop. This differentiates it tonally from the top of the subject's head.

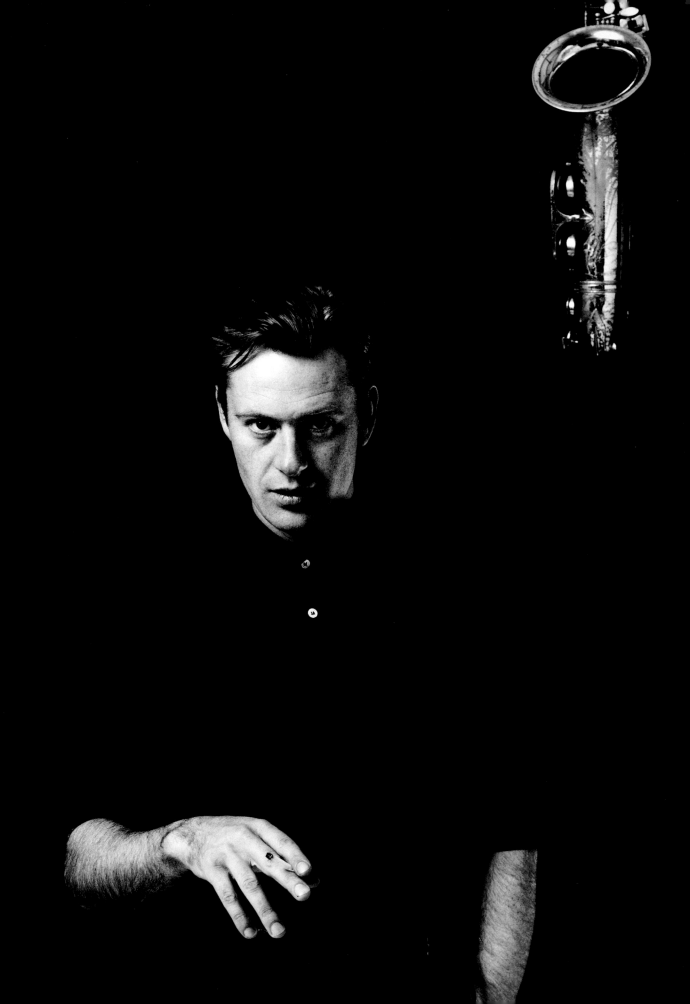

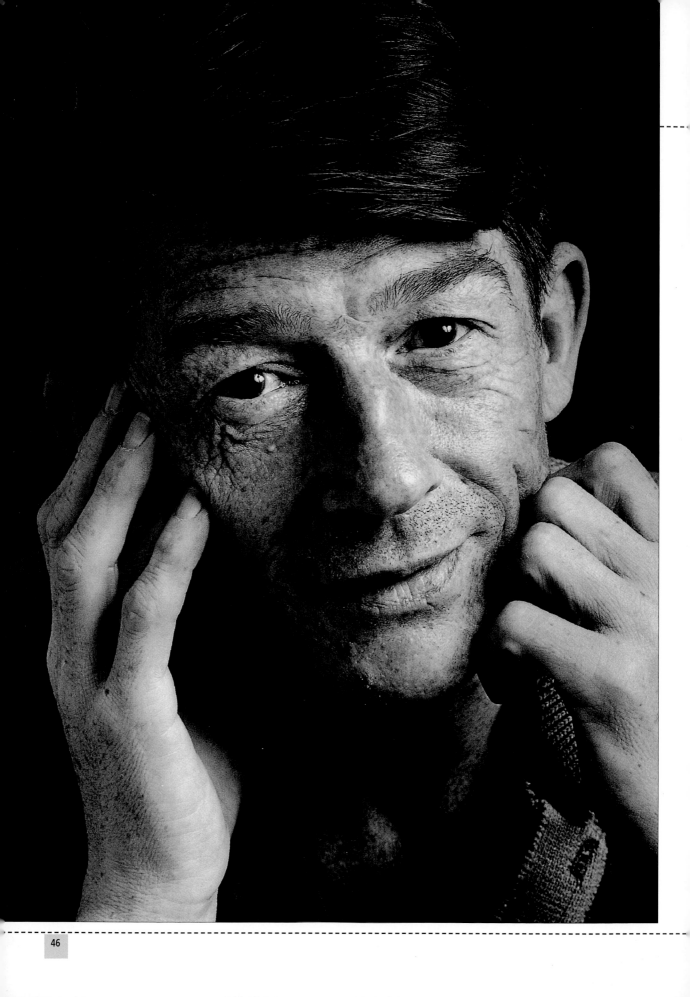

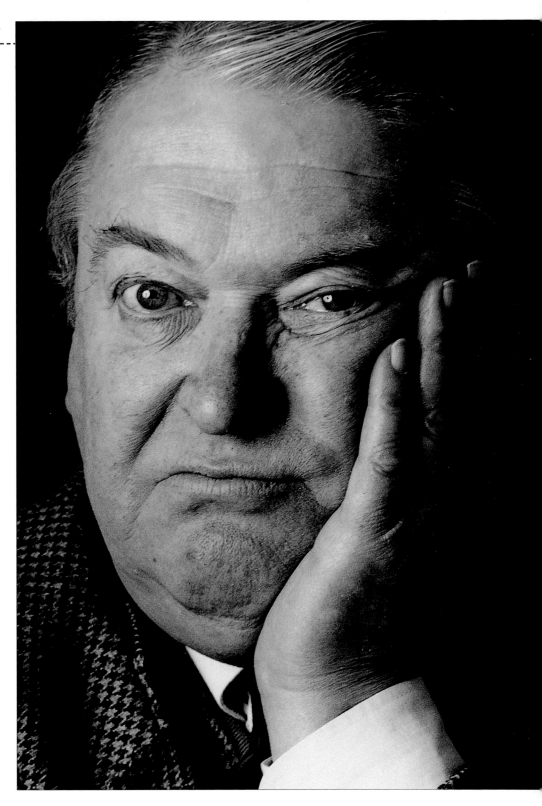

◀ ▶ A similar approach has been adopted by the photographer of these two personalities – the actor John Hurt (left) and novelist and poet Kingsley Amis (right). For both portraits, the lighting is indirect – a single studio flash fitted with an umbrella reflector.

PHOTOGRAPHER:
Trevor Leighton

CAMERA:
6 x 7cm

LENS:
120mm

EXPOSURE:
¹⁄₂₅ second at f11

LIGHTING:
Studio flash and umbrella reflector

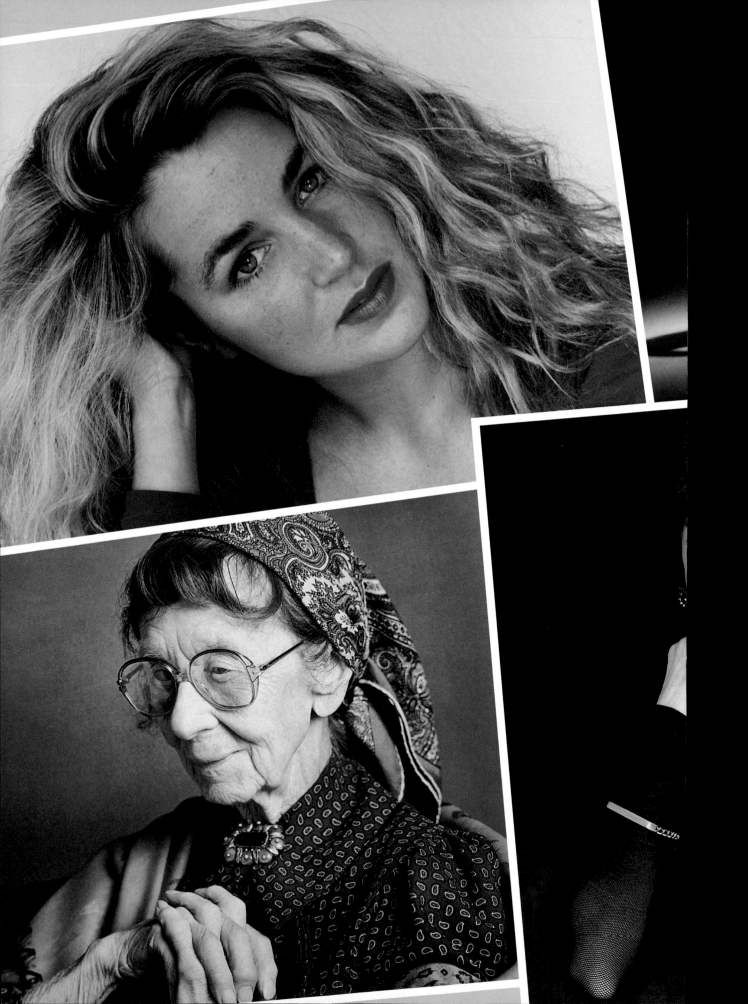

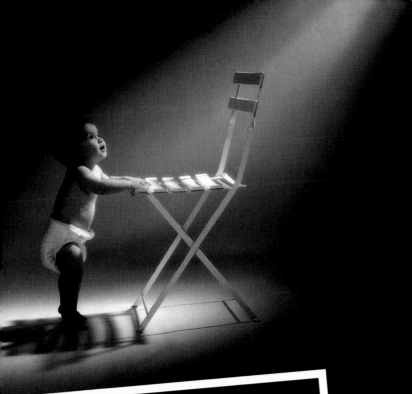

THE FOUR AGES

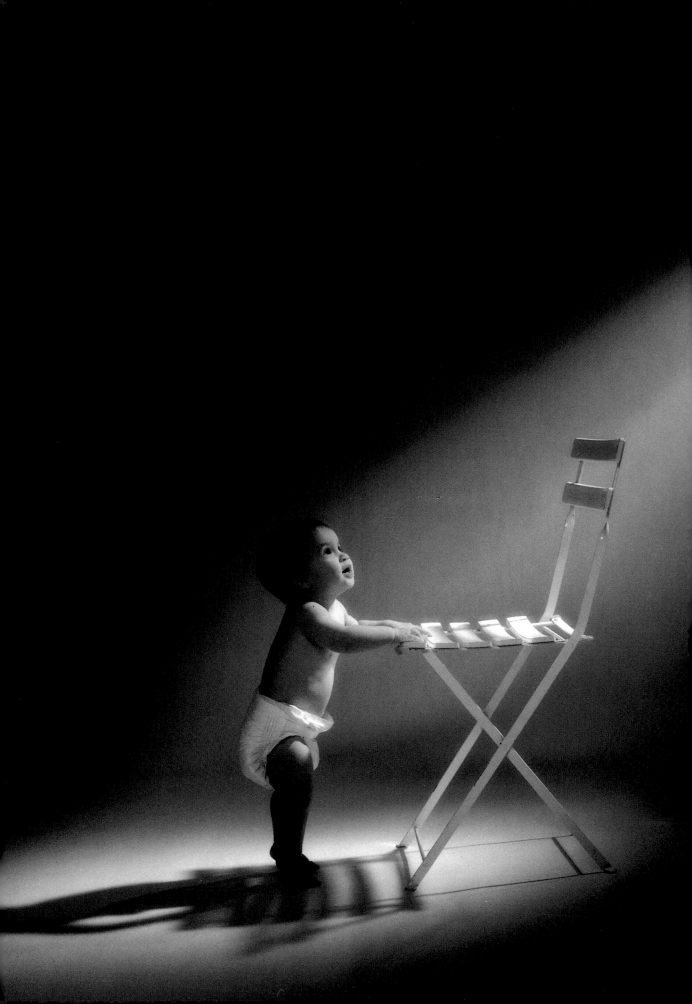

BABIES AND TODDLERS

One of the main problems when photographing babies and young toddlers is that they are not able to support themselves – at least, not reliably so. This means that they often have to be shown either with an adult cradling or otherwise supporting them, or with some other object on the set that they can hold on to. In fact, this can often be turned to your advantage, since it is then possible to emphasize their diminutive size.

Your approach to photographing babies and toddlers has to be very different to the way you would tackle a portrait of an older child or adult. First of all, since your young subject will not realize who you are or what you are doing, you cannot expect any active co-operation. Instead, you will have to be patient and rely on your reflexes not to waste any photo opportunities that occur. Also bear in mind that the movements of babies are not predictable, so you need to use a lens focal length and camera position that allow a little space around the subject in case of any sudden, unexpected movements. The height of the camera and lights is also critically important. If lights are set too high the subject will be basically toplit, which could result in unattractive shadows being cast down over the face. In most situations, the height of the camera should be at about the level of your subject's eyes. If you shoot from a camera position suitable for an adult, you will be looking down on the child, making him or her seem even smaller.

PHOTOGRAPHER:
Jos Sprangers

CAMERA:
6 x 6cm

LENS:
85mm

EXPOSURE:
1/25 second at f8

LIGHTING:
Tungsten spotlight

◀ *The lighting in this portrait, a tungsten spotlight, is an integral part of the image. Its beam has been made more visible in the darkened studio by the addition of just a little well-dispersed smoke in the air.*

Hints and tips

● A young child will be happier and more relaxed if the surroundings are warm and comfortable and his or her mother is close at hand. Soothing background music is a good idea, too.

● Keep photographic sessions short so as not to tire your young subjects – about 15 to 20 minutes is probably the upper limit.

● With luck, after the first two or three firing of the flash, a baby will soon learn to ignore these sudden explosions of light. If the baby will not settle, however, it may be better to use daylight or continuous tungsten.

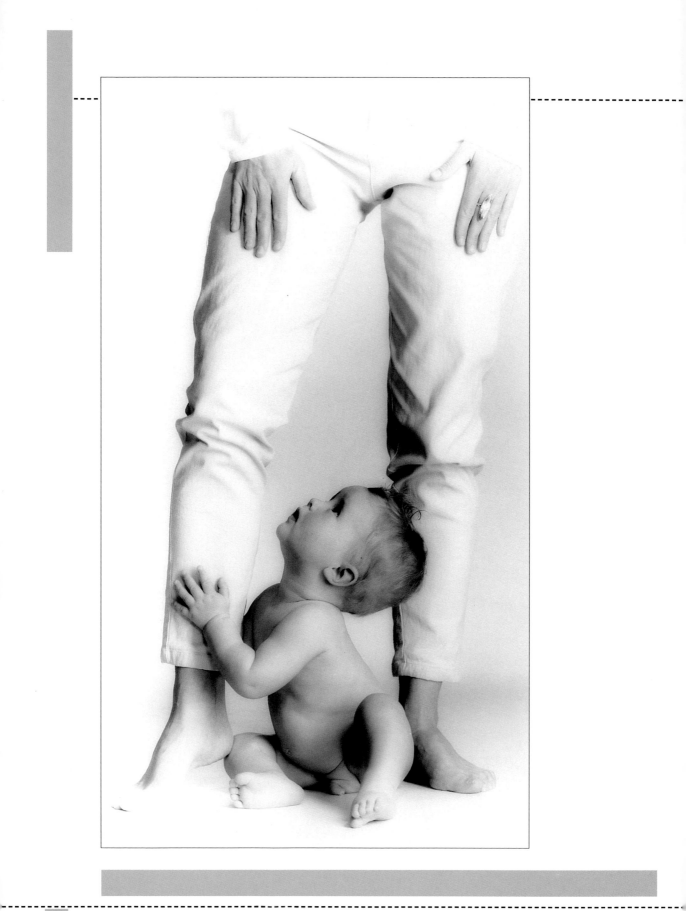

◀▶ *In both of these photographs, a parent has been included in the set-up to support the tiny subjects. Both of the babies have obviously drawn comfort from their presence and they look very relaxed. By introducing an adult, you can readily see just how small they are.*

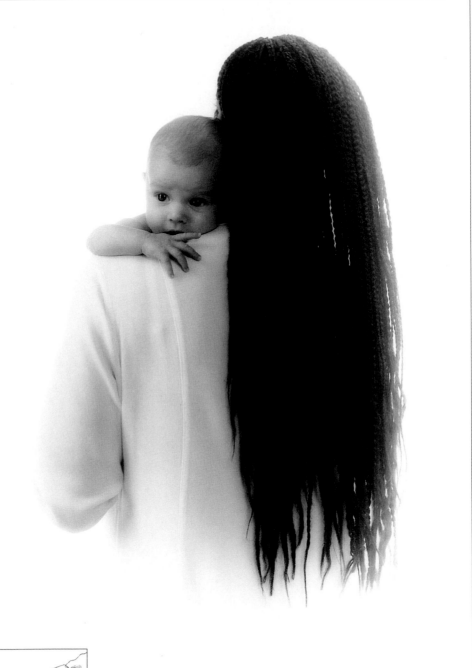

PHOTOGRAPHER:
Jos Sprangers

CAMERA:
6 x 4.5cm

LENS:
105mm

EXPOSURE:
½₅₀ second at f5.6

LIGHTING:
Studio flash with softbox

◀ *To make a white vignette, print the image through a piece of stiff opaque cardboard with a hole cut in it corresponding to the part of the image you want to be seen. Where the cardboard blocks the light from reaching the printing paper, no tone will appear.*

NOVELTY PORTRAITS

Since most children enjoy being the centre of attention, it is usually not too difficult to encourage them to dress up for the camera for a series of novelty portraits. And things will go far smoother if you turn the photographic session into a game.

With the session illustrated here, the child was initially a little hesitant about posing in front of the stand supporting the angel's wings and halo. To encourage the right atmosphere, the photographer's assistant was the first up in front of the lights. By taking a

few frames of his assistant, the photographer was able to show the girl that she was there to have fun, and that the studio flashes were nothing to be frightened of. Even so, there was an adult present the child knew throughout the entire session.

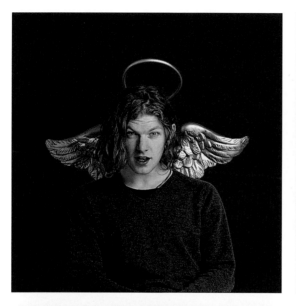

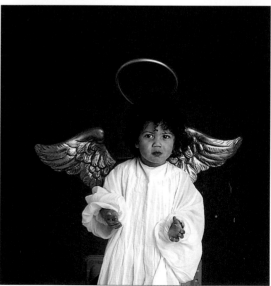

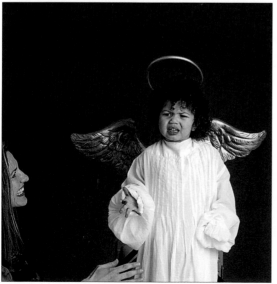

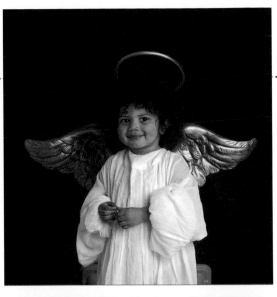

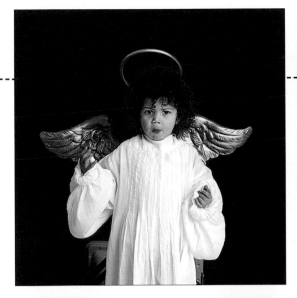

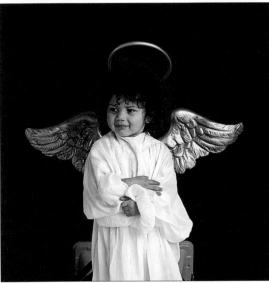

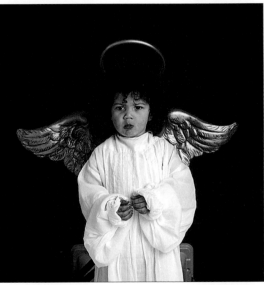

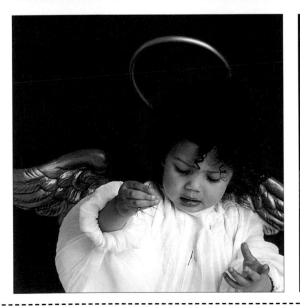

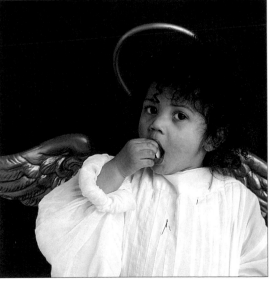

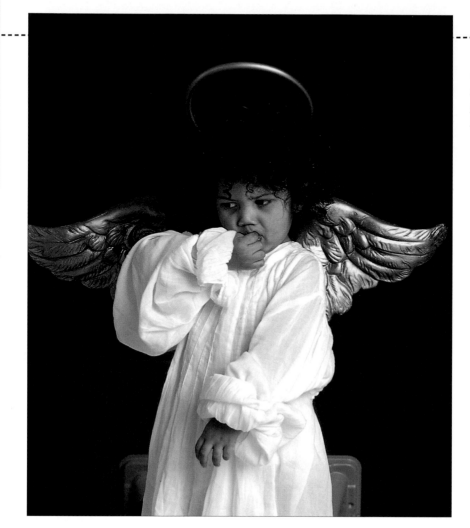

PHOTOGRAPHER:
Anthony Oliver

CAMERA:
6 x 6cm

LENS:
120mm

EXPOSURE:
¹⁄₆₀ second at f11

LIGHTING:
Studio flash with softboxes x 2

◀ *Two studio flash units, both fitted with softbox diffusers, were positioned either side of the camera. Because of the diminutive size of the subject, both lights were set low down to ensure that the little girl's face was properly lit.*

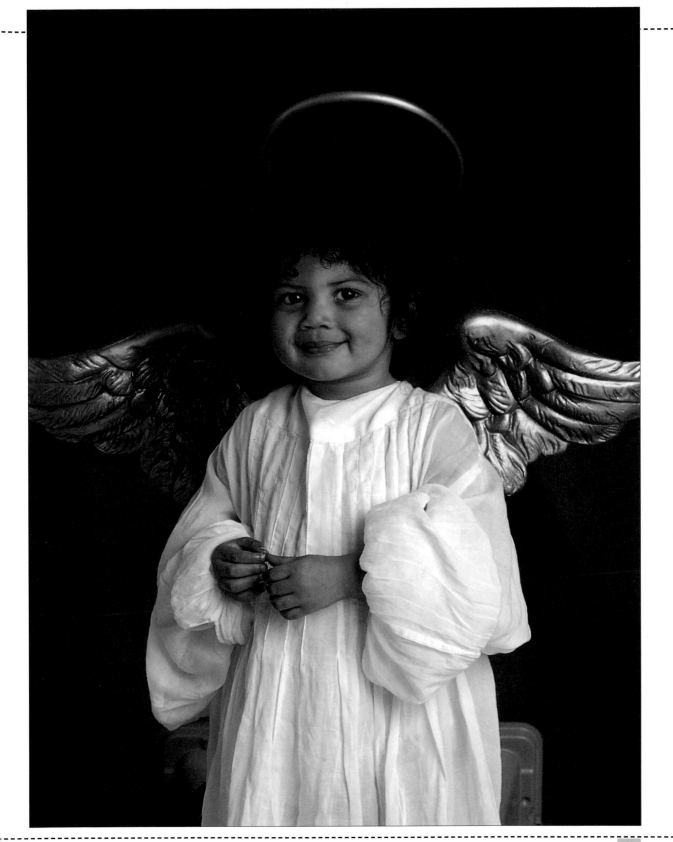

FLEXIBLE WORKING

Older children are a mixed blessing in the studio. They can be refreshing to photograph because they tend to be uninhibited – once the initial shyness has been overcome – and are usually very willing to co-operate. This is especially true if you introduce some fun and play elements into the photo session.

On the down side, children's concentration span is extremely limited and their moods can swing wildly from laughter to tears in a matter of seconds. You will almost certainly lose their attention if you spend too much time fiddling with lights or reflectors and adjusting backgrounds between shots, and then you will probably have to spend most of the session coaxing them back onto the set and settling them down once more.

You can minimize a lot of problems if you create a base for your young subjects for the session. Once they accept it as "their territory" you have a focus around which you can set your lights. In the example here, and on the following pages, a chair has been used in just this way. Once you know where physically the child will be, set about arranging your lights. Only at the last minute call your subject onto the set for a light reading and any last-second adjustments.

Aim for a broad lighting scheme, relying more on photofloods or flash units with flash umbrellas and large reflector boards, rather than spotlights. You don't want a situation where a sudden turn of the head or an unplanned fidget in the chair destroys a too-precise lighting scheme.

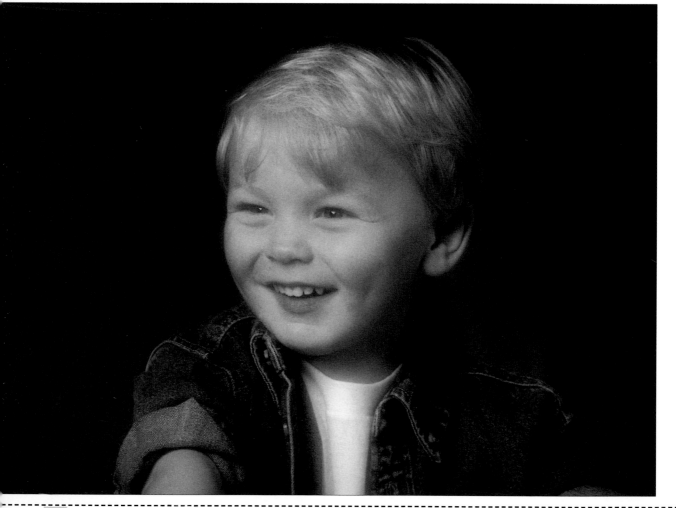

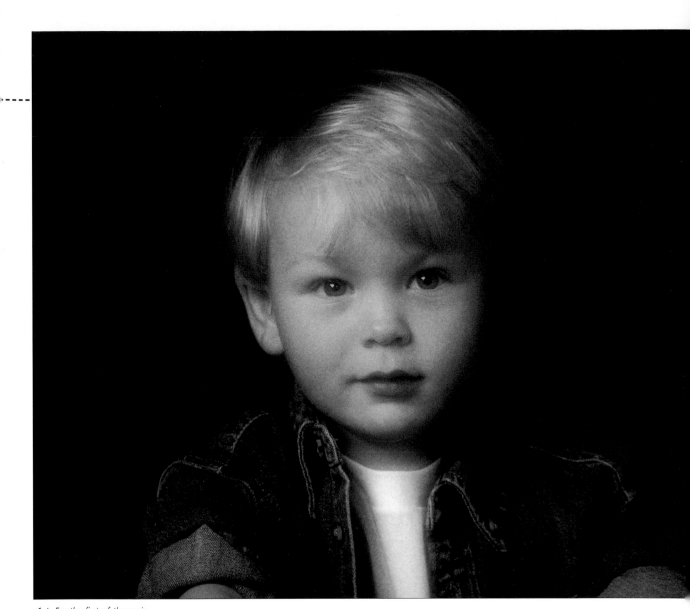

◀ ▲ For the first of these pic-tures (left), the little boy's mother was helping by talking to him and telling him stories to try and make him laugh. To record a variety of facial expres-sions, for this next shot (above) the photographer called out the boy's name and quickly snapped him as he looked around in response.

PHOTOGRAPHER:
Gary Italiaander

CAMERA:
6 x 4.5cm

LENS:
100-200mm

EXPOSURE:
⅟₆₀ second at f8

LIGHTING:
Studio flash x 2, one with umbrella, and large reflector boards

EFFECTS:
Diffusion filter used for black and white photo-graphs during printing

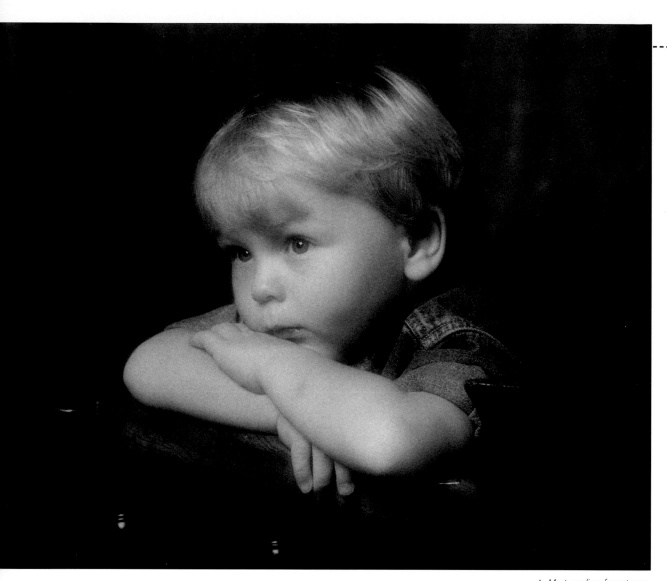

▲ Most medium-format cameras are ideal for studio work when you want to take a mixture of colour and black and white – all you need do is remove the film back, even in mid-roll, and snap on another preloaded with the other type of film. The first shot of this pair (above) is in black and white. However, as the photographer paused to change films the boy started to take an interest in what he was doing, which resulted in the second colour shot (above right) of him staring intently at the camera.

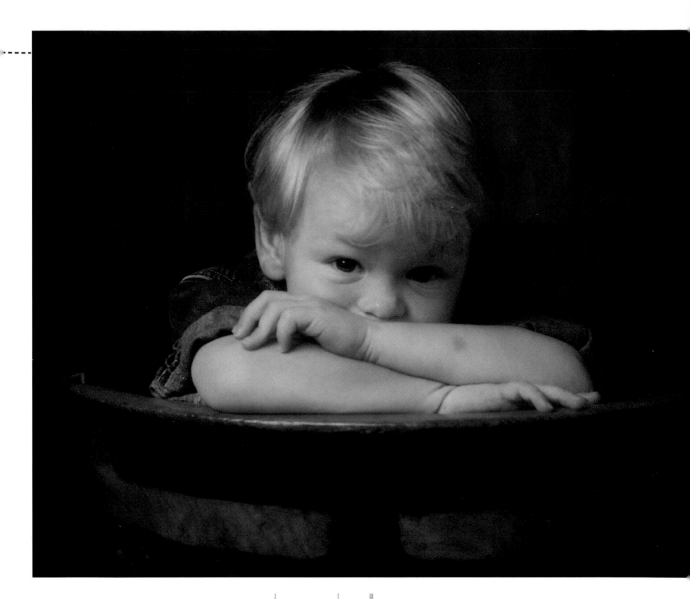

◀ To create an easy and flexible lighting scheme that didn't rely on the subject adopting a precise pose, the main light was set up to the left of the camera. This flash unit was fitted with a flash umbrella to produce a broad spread of illumination. In an arc on the other side of the subject, large white reflectors were set up to confine and reflect the light within the area around the chair. Between the boards, a second flash unit without reflector was used to create localized highlighting.

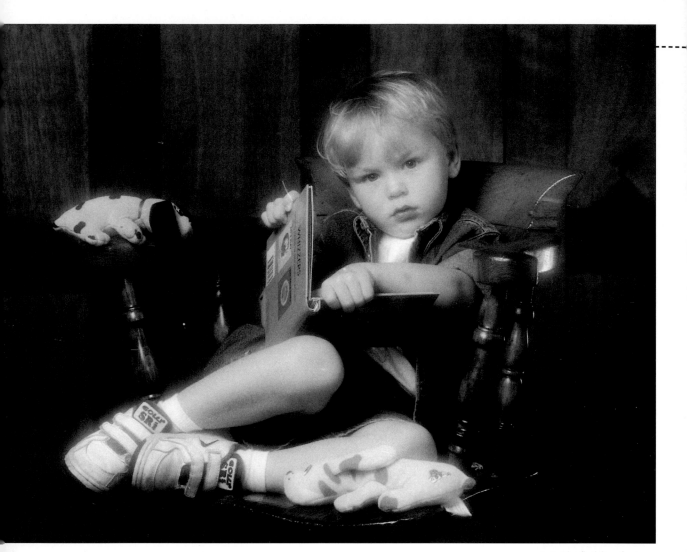

Hints and tips

● Provide a few toys, games, and books for children to use while in the studio. This will prevent them from becoming bored as they wait for their turn in front of the camera and lights.

● All children should be accompanied by a responsible adult while in the studio.

● You will elicit more co-operation from children if you make their studio session into a fun time for them.

● Using a zoom lens will allow you to vary subject framing, from close-ups to full-length shots, from about the same camera position and without having to alter the position of lights. Zooms also allow you to capture fleeting facial expressions that you would almost certainly miss if you had to change lenses.

▲ ▶ *The flexibility of using a zoom lens is demonstrated by these two photographs. Both were taken from about the same camera position as the previous ones in this set, but here the boy can be seen in the equivalent of a full-length portrait. The toys and books can also be seen here being put to good use.*

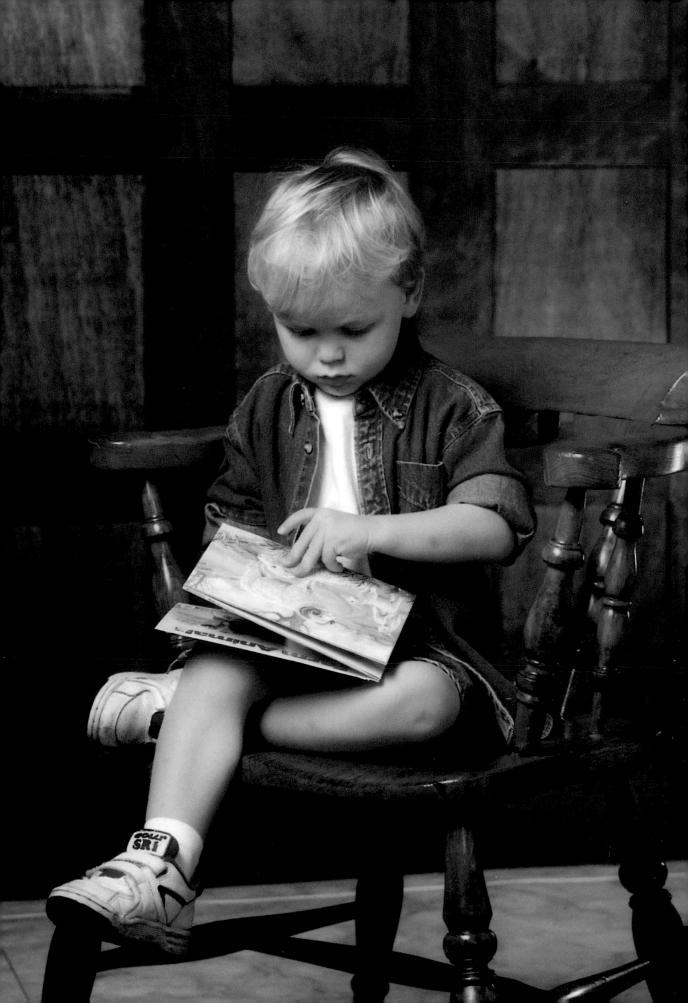

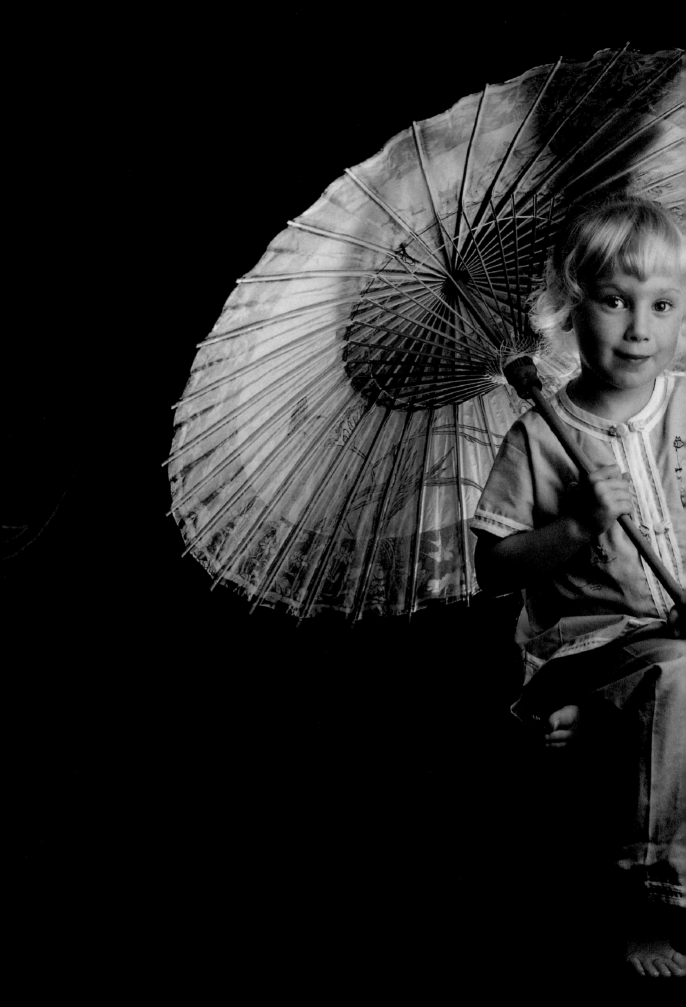

BACKLIGHTING

One of the most commonly used studio lighting schemes is based around a three-light set-up: a main light, a fill-in light, and a toplight. The main light, as its name implies, provides the principal illumination for the subject, or subjects. This light is often positioned somewhere to one side or the other of the subject to provide directional lighting.

The fill-in light will usually either be of less power than the main light or be positioned further back from the subject so that its light has less effect. Often, this light is positioned on the other side of the subject from the main light in order to lighten – or fill-in – the shadow areas on that side. Sometimes you will find that the fill-in light is substituted by a large reflector, which serves the same function by reflecting light from the main light back onto the subject's shadow side.

The toplight is used most often above the subject's eyeline, illuminating, say, the persons head and shoulders. One of the functions of this light is to help to differentiate the subject from the background.

When the top light is taken further around the subject, so that its light strikes the subject from the rear, this is known as backlighting. This type of lighting scheme is most often employed to produce what is known as rimlighting – a halo-like effect surrounding the subject's head and shoulders. As well as being an attractive lighting effect in its own right, backlighting more strongly separates the subject from the background than does toplighting.

◀ *In this portrait, the main light to the right of the camera and the fill-in light to the left were supplemented by a light positioned behind the subject's back. From here, its light floods through the paper umbrella she is holding and produces an attractive rim of illumination around her wispy hair, shoulders, and arm.*

PHOTOGRAPHER:
Gary Italiaander

CAMERA:
6 x 6cm

LENS:
120mm

EXPOSURE:
⅟₆₀ second at f5.6

LIGHTING:
Studio flash x 3

FORMAL PORTRAITS

Babies and toddlers can't be directed into specific poses and so the photographer needs to adopt more of a candid approach, picking off shots as and when the opportunities arise. With older children, however, there is the option of taking more formal portraits.

As with portraits of adults, which follow later in this chapter, the photographer has to make great efforts to record something of the subject's character and personality. A friendly and chatty approach often works well, helping the child or children to relax and express themselves in front of the camera. But beware of being patroniz-

ing or condescending – children are intuitive, often more so than adults, and they may become unresponsive if they feel you are being insincere.

Whether or not to shoot a formal portrait in the studio or in the subject's home depends very much on the personality of the child concerned. Some children might love the adventure aspect of visiting the studio and so respond well to the situation. Others, however, might go "wooden" in the same situation and would be better photographed at home where they are surrounded by all the familiar things that make them feel safe.

PHOTOGRAPHER:
Gary Italiaander

CAMERA:
6 x 6cm

LENS:
90mm

EXPOSURE:
⅛₂₅ second at f8

LIGHTING:
Studio flash x 2

Hints and tips

● Allow a little time before the photography session actually starts so that the children can become used to both you and your equipment.

● To encourage a spirit of co-operation between you and your subjects, let them look through the viewfinder of the camera while you pose in front of the lens.

● If the children are interested and ask questions about what you are doing and why, take the time to give as full an explanation as you think they will understand.

● If children seem nervous and unrelaxed, make the first few exposure without any film in the camera. When they have become used to the clunking of the shutter and the flash of the lights they may relax more and make better subjects.

● Keep the photographic session short. A child's attention span is less than that of most adults.

▶ *A well-composed studio portrait of a young sitter turned sideways to the camera but with her head turned to produce a three-quarter view. The formality of the pose is nicely set-off by her simple string of pearls and the addition of just a little lipstick to bring out the colour in her lips.*

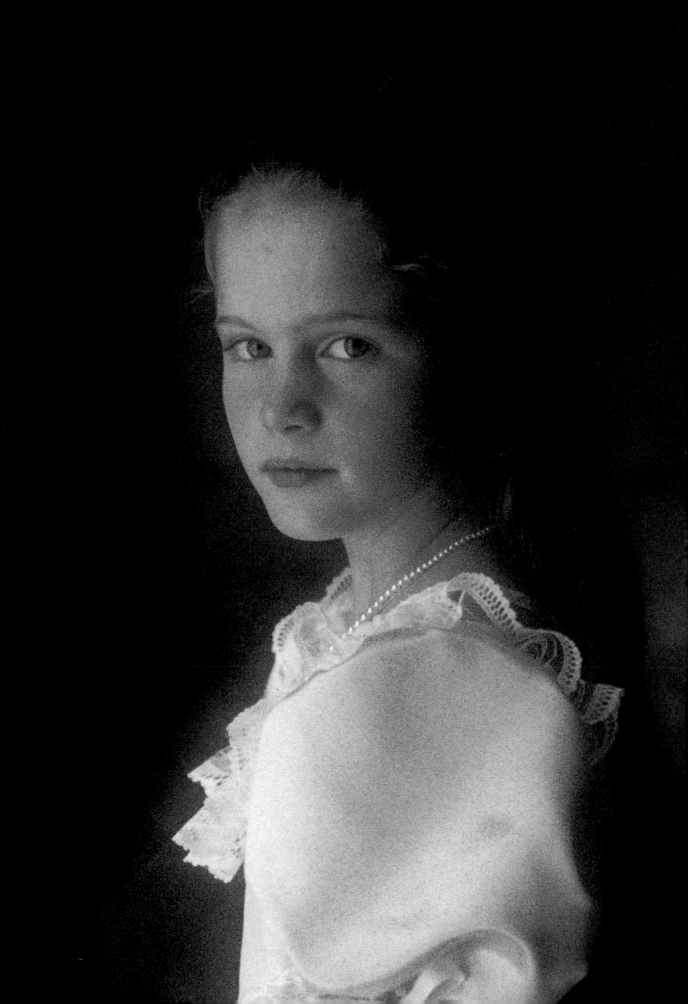

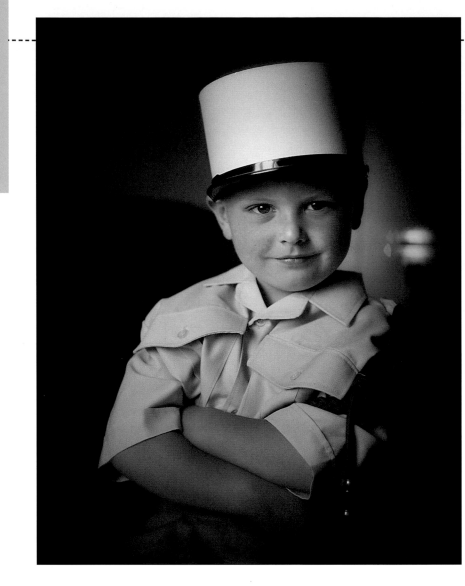

◀ Scrubbed clean and neatly pressed, this young sitter is obviously extremely proud of his Foreign Legion uniform. The background to the subject is domestic, but the lens aperture was large enough to produce such a limited depth of field that any detail was reduced to a blur. The lighting is flash, diffused and low-key, but the tungsten table lamp that can be seen shows up as a warm and pleasant orange cast on the film, which was balanced for flash and daylight.

PHOTOGRAPHER:
Nigel Harper

CAMERA:
35mm

LENS:
90mm

EXPOSURE:
½₂₅ second at f8

LIGHTING:
Studio flash heavily diffused

PHOTOGRAPHER:
Nigel Harper

CAMERA:
35mm

LENS:
70mm

EXPOSURE:
½₂₅ second at f4

LIGHTING:
Accessory flash heavily diffused

▶ Much of the appeal of this charming portrait is due to the young subject's pose, which is reminiscent of the type you would expect to be adopted by an older person. The lighting is soft and gentle and her upturned glance toward the camera helps to emphasize the shape and size of her eyes. A lens diffusion filter with a clear centre spot has created a slightly soft-focus effect around the periphery of the frame.

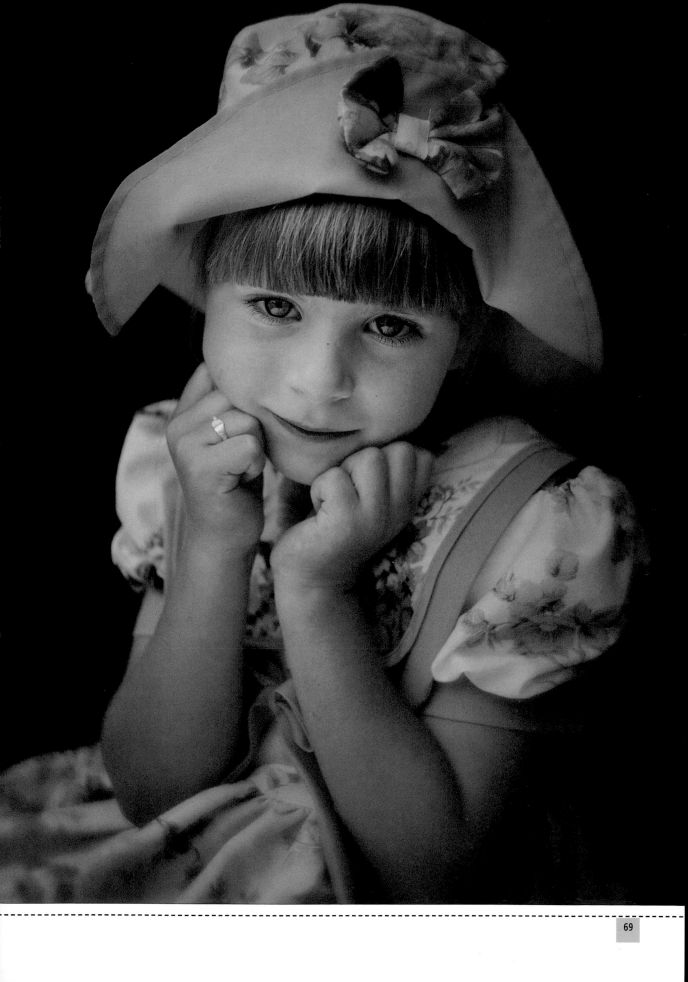

INFORMAL PORTRAITS

I t is the very variability of children's moods that makes them such interesting and challenging subjects for the portrait photographer. If your intention is to take informal portraits, then you should try to intrude as little as you possibly can on your subjects. And their own homes may be a better venue than a studio, where they are less likely to feel relaxed. For the first few minutes after your arrival, they will be naturally curious about you and your equipment, but it won't be long before they become engrossed once more in their own activities – giving you the chance to start work.

Which lens?

For informal portraiture, which is like candid photography in many respects, it is better if you can distance yourself as far as possible from your subjects. In this way, your presence won't unduly influence their activities. For the popular 35mm camera format, one of the best lenses to use is a 135mm telephoto. With this lens you should be able to fill the frame with a head-and-shoulders shot from a distance of about 3 metres (10 feet). A telephoto lens with a wide maximum aperture is best (say, about f2.8) because you will be able to shoot in quite poor light without flash while maintaining a shutter speed brief enough to freeze most normal subject (and camera) movement. As lenses become longer, they also become heavier, making some sort of camera support essential to prevent camera shake. But for flexibility of framing, an excellent choice of lens is a 70-210mm zoom, although with most zooms you will have to sacrifice a little lens speed.

PHOTOGRAPHER:
Nigel Harper

CAMERA:
35mm

LENS:
80-210mm zoom

EXPOSURE:
⅟₆₀ second at f11

LIGHTING:
Daylight only

▶ *Taken with a telephoto zoom lens, this informal and very relaxed portrait takes advantage of the difference in exposure between the boy's face and his shadowy surroundings to suppress the background. The picture was taken indoors by window light.*

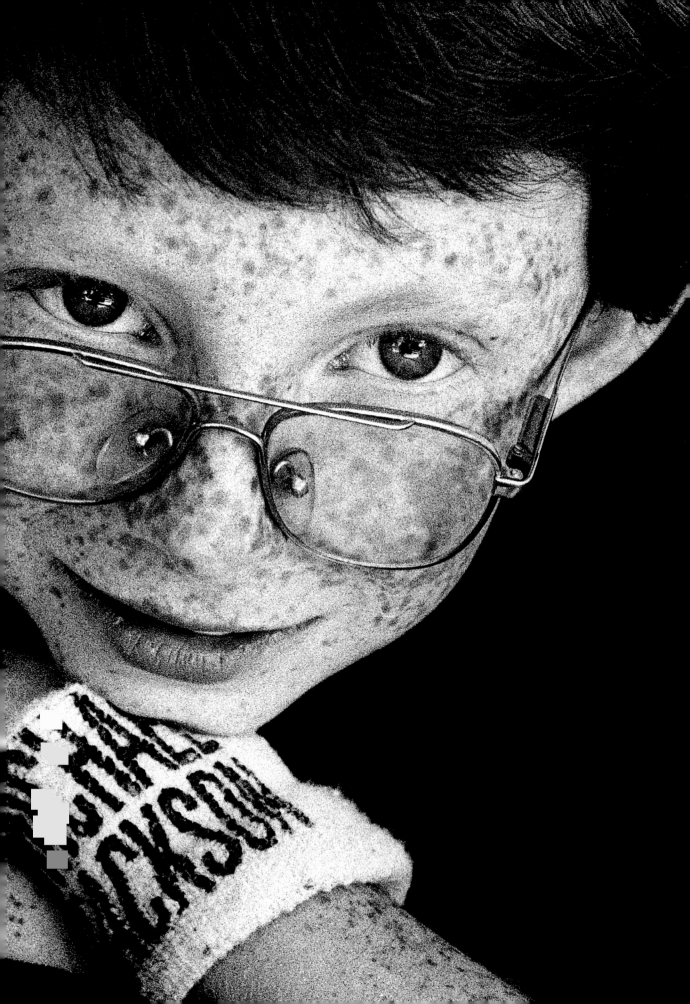

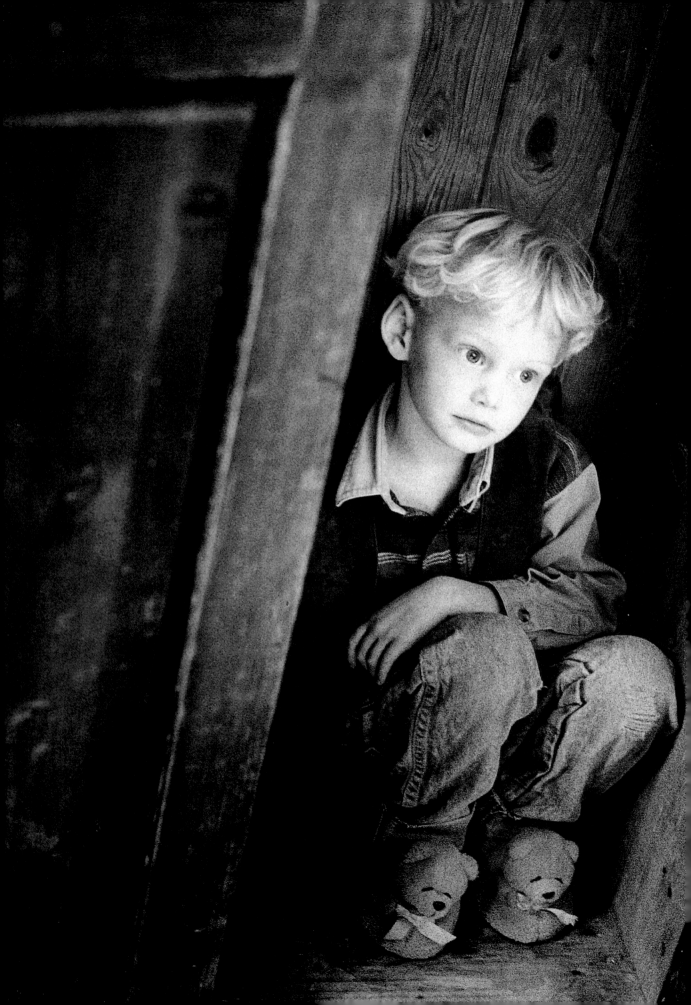

◄ Caught totally unawares by the camera, this young boy had taken himself off to his private thinking place just outside the back door of his house and the picture was taken from indoors through an open window.

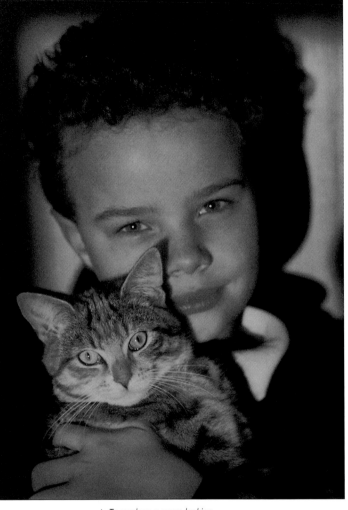

PHOTOGRAPHER:
Nigel Harper

CAMERA:
35mm

LENS:
135mm

EXPOSURE:
⅟₁₂₅ second at f5.6

LIGHTING:
Daylight only

▲ To produce a warm-looking type of light, the photographer used an orange-coloured filter over the camera lens. The general colour cast produced as a result is reminiscent of the light from an open fire. The main illumination was an accessory flash unit, direct and undiffused, but slightly to the left of the camera position to make the light more directional.

PHOTOGRAPHER:
Majken Kruse

CAMERA:
35mm

LENS:
90mm

EXPOSURE:
⅟₆₀ second at f8

LIGHTING:
Accessory flash

FAMILY PORTRAIT

This portrait, of the photographer's daughter, is technically the type of result you could expect to achieve in an averagely equipped home studio. The subject has been lit entirely by artificial light – a single studio flash unit fitted with a softbox, which spreads and softens the illumination, and a reflector on the far side of the subject to relieve the shadows slightly.

The key to the impact of this portrait lies in its simplicity and it eloquently makes the point that it is not the equipment used that determines the success of any particular photograph; rather, it is the perception and talent of the photographer.

Even when looked at in detail, the image is virtually free of any signs of graininess. The skin of the subject is smooth and flawless, and every ringlet of hair is clearly defined. Modern emulsions, especially the slower types such as the one used here, which is ISO 100, will tolerate a high degree of enlargement before grain becomes a concern.

PHOTOGRAPHER:
Linda Sole

CAMERA:
6 x 6cm

LENS:
150mm

EXPOSURE:
1/125 second at f5.6

LIGHTING:
Studio flash with softbox and reflector

EFFECTS:
Diffusion filter

▲ The studio flash and softbox provided the principal illumination here, with the reflector board used to lighten the shadow a little and prevent the lighting becoming too contrasty. To mask off the rest of the studio, black background paper was used. This was positioned well behind the subject to prevent any stray light from the flash spilling over onto it and producing an unwanted grey tone.

▶ In order to soften the image slightly a diffusion, or soft-focus, filter was used over the camera's lens. Then, during printing, the image was further softened by printing it through another diffusion screen.

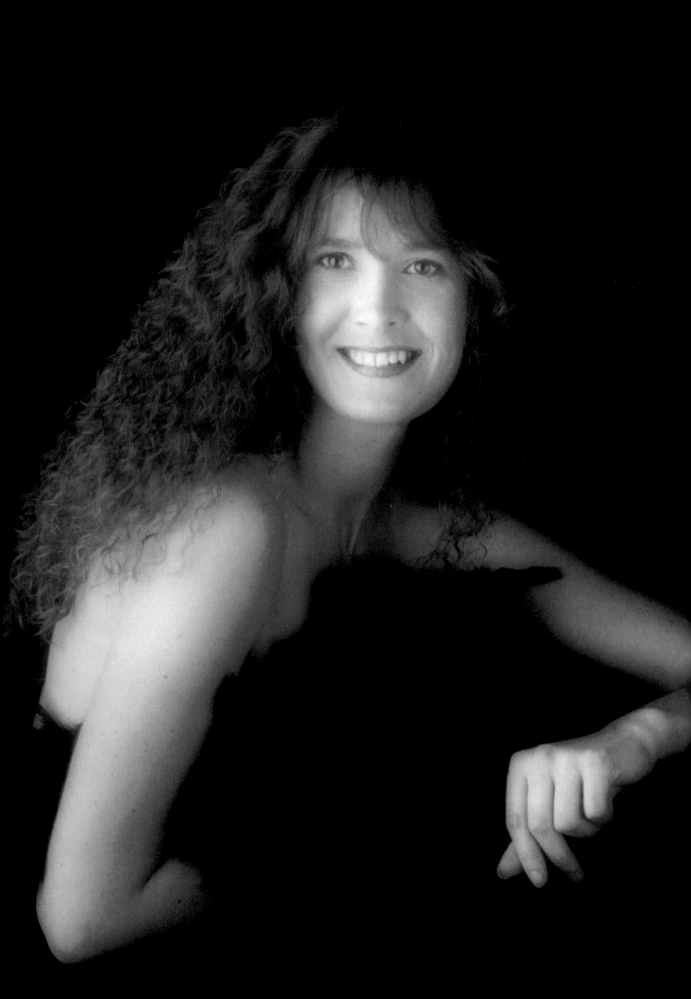

ON LOCATION

Not all photographers favour the studio approach to portraiture, or even necessarily have their own studio in which to work. However, most will at least have access to studio facilities, which can be hired by the hour or day, whenever the necessity arises.

Not having a studio base is by no means a disadvantage. Indeed, many potential clients prefer the photographer to visit them at home to discuss the approach to be adopted for a portrait session and then to take the pictures there on location. People can find the studio to be a strange and rather forbidding place, and simply can't sufficiently relax and allow their "real selves" to come through in front of the camera.

When visiting a client's home with a view to using it for photography session, pick a time of day that corresponds to the time the actual session will take place. In this way, you will be able to look at each room, note where the windows or balconies are located in relation to walls and so on you may want to use as backdrops, and see exactly how much natural light you will have to work with.

It is not only the quantity of light that is a consideration; you also need to asses its quality. Daylight flooding in through large picture windows, for example, may be far too overpowering for the type of images you want to produce. In this type of situation, make sure you take along with you on the day some sort of diffusing material, such as sheets of tracing paper, that can be temporarily stuck onto the glass to manipulate lighting quality.

PHOTOGRAPHER:
Majken Kruse
CAMERA:
6 x 6cm
LENS:
105mm
EXPOSURE:
⅙₀ second at f8
LIGHTING:
Diffused daylight

▶ *The light for this home portrait came from a large picture window immediately to the subject's left. Even with the blinds drawn, as they are in the picture here, the light was still far too bright, and so lengths of fine gauze, similar to the material used for some net curtains, were taped to the glass to act as a diffuser.*

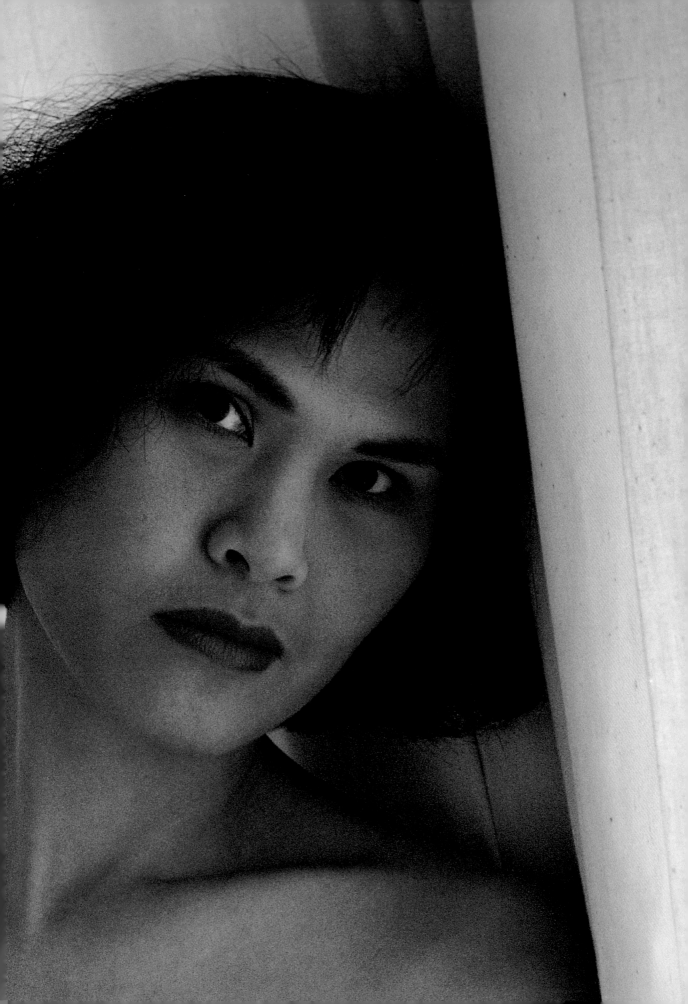

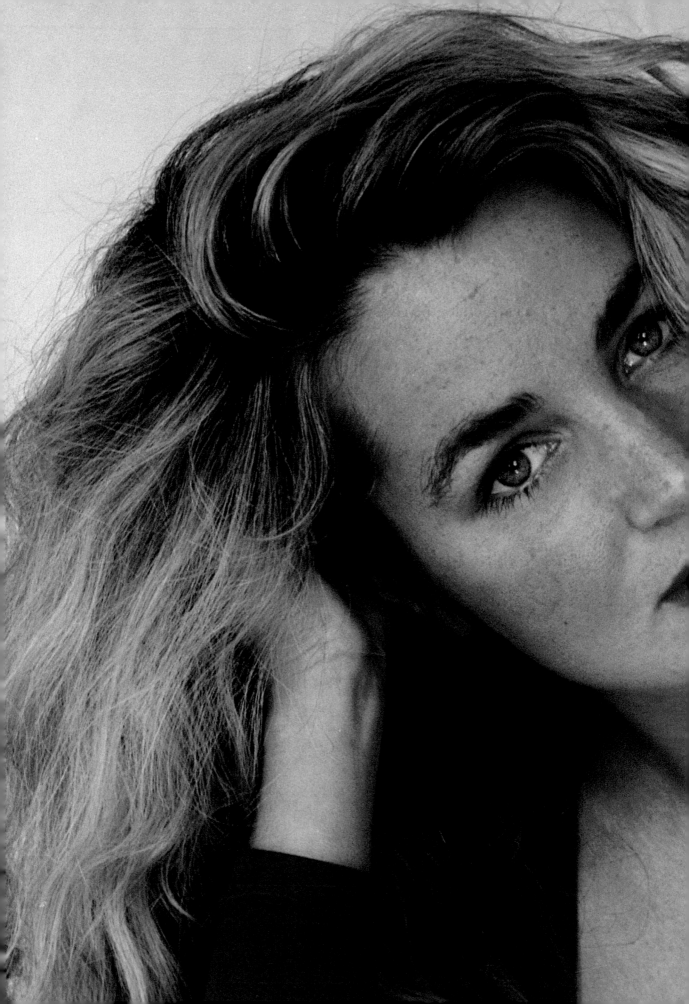

◀ Because the light levels in the room in which this photograph was taken were extremely poor, they had to be supplemented by two accessory flash units with layers of tracing paper taped over their lighting heads. Both flashes were slightly elevated to ensure that any shadows cast by the subject onto the wall behind would be masked by her own body, and so would not be visible in the final photograph.

PHOTOGRAPHER:
Majken Kruse
CAMERA:
6 x 4.5cm
LENS:
90mm
EXPOSURE:
⅟₁₂₅ second at f8
LIGHTING:
**Diffused flash x2
and daylight**

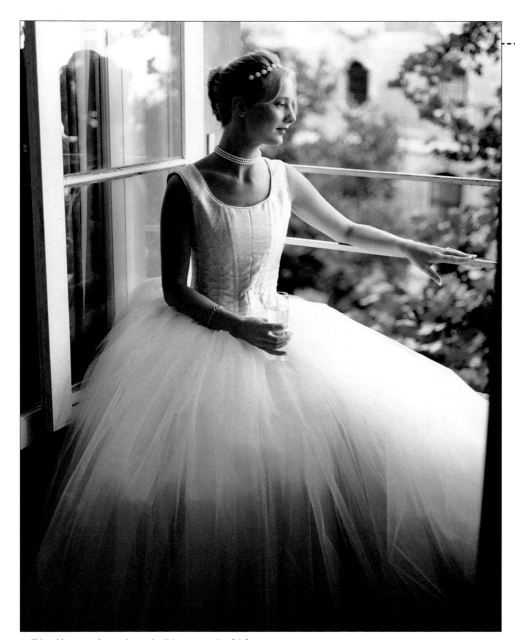

▶ Bright light from a mid-morning summer's sun was the only illumination needed for this evocative portrait. Being in her own home, the subject was completely at ease and the photographer adopted more of a candid approach to the session. During the morning, the photographer used the camera to pick off shots as the client basically went about her normal routine, and directed and fine-tuned her poses only when absolutely necessary.

PHOTOGRAPHER:
Majken Kruse

CAMERA:
6 x 4.5cm

LENS:
80mm

EXPOSURE:
½₂₅ second at f4

LIGHTING:
Daylight only

▲ This subject was due at the church for her wedding later that morning, and so the photographer had only limited time to take pictures. All the rooms of the apartment were either full of people or cluttered with pre-wedding paraphernalia, and so the best place for the portrait was a small balcony off the living room. Careful framing shows the bride free of the chaos that really existed in the room at the time, seemingly with all the time in the world to relax and drink a glass of champagne. By selecting a large aperture, the background has been thrown sufficiently out of focus not to intrude.

PHOTOGRAPHER:
Majken Kruse

CAMERA:
35mm

LENS:
50mm

EXPOSURE:
½₂₅₀ second at f16

LIGHTING:
Daylight only

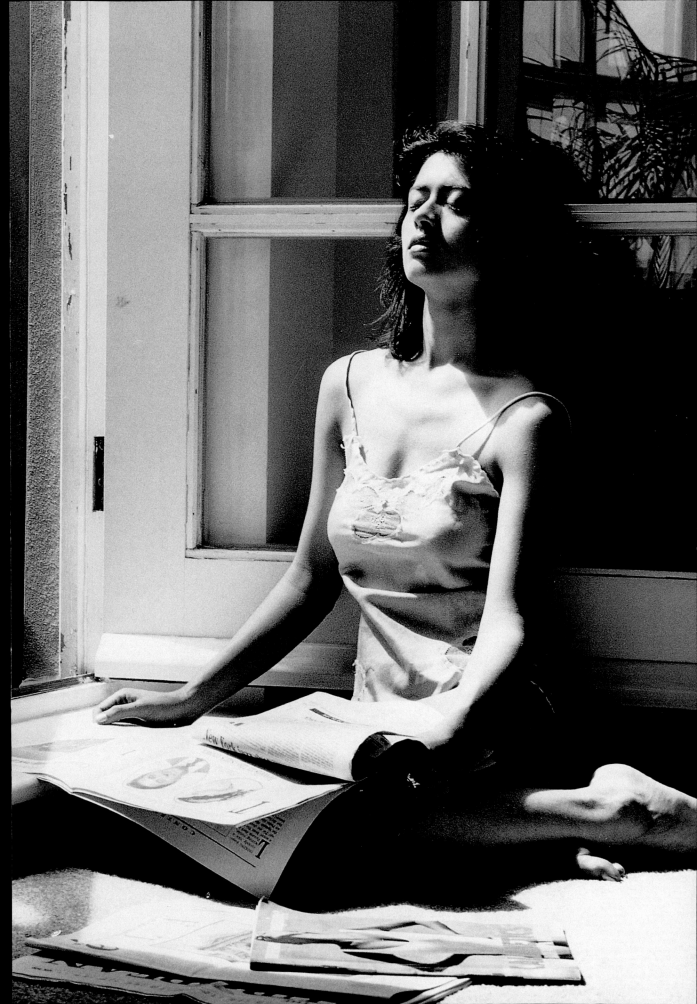

VARIATIONS ON A THEME

All manner of people commission portrait photographs for all types of reason. Some people have their portraits taken at set intervals every few years, for example, so that they have a record of the physical changes that occur with the passage of time; others may want a portrait taken to give to a friend or loved one who is going away for an extended period; yet others may want a record of an important occasion or event in their lives, such as graduation from school or college, a wedding, or anniversary.

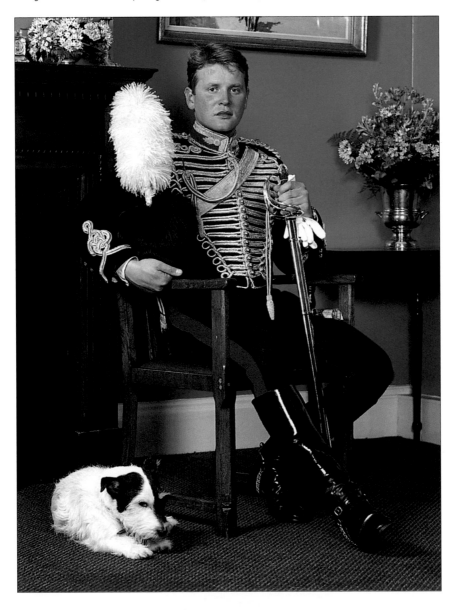

◄ ► *The subject of these two photographs, a captain in the Guards, was photographed in a traditionally formal military pose, seated in a high-backed chair. The two uniforms he is seen in – one his ordinary service uniform, the other a magnificent full ceremonial uniform with plumed bearskin helmet and dress sword – were obvious themes to incorporate into the photographic session. The inclusion of the Guardsman's pet dog produces an informal and slightly humorous note in what is otherwise a very formal composition.*

PHOTOGRAPHER:
Julian Deghy

CAMERA:
6 x 7cm

LENS:
180mm

EXPOSURE:
⅟₆₀ second at f11

LIGHTING:
Studio flash x 2, plus flash umbrellas

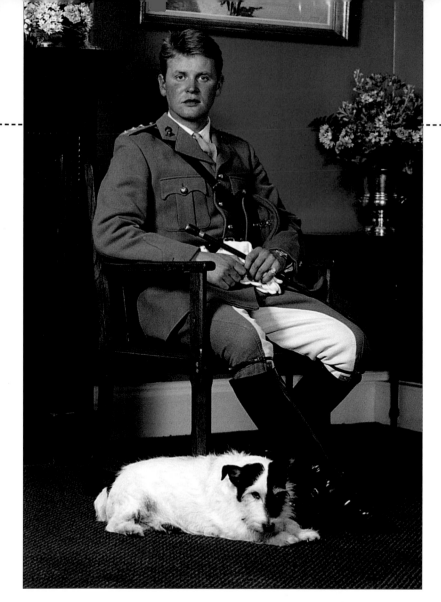

◄ *A directly head-on view would have been unsatisfactory here because of the shape made by the subject's legs. The most elegant solution was to angle the chair slightly and have the subject turn his face directly toward the camera. The main flash was set up to the left of the camera, while the secondary, or fill-in, flash was at the same distance to the right of the camera, powered down to produce a less intense light.*

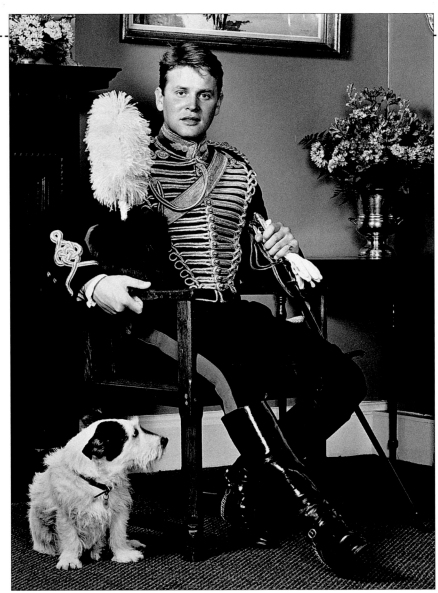

◄ The original of this portrait variation was taken on black and white film stock and the print was then treated with a commercially available selenium toner. The use of this toning agent deepens the blacks and strengthens image contrast. As well, selenium toner can be used to archivally stabilize prints.

PHOTOGRAPHER:
Julian Deghy

CAMERA:
6 x 7cm

LENS:
180mm

EXPOSURE:
⅟₆₀ second at f22

LIGHTING:
Studio flash x 2, plus flash umbrellas

▶ For this image from the portrait session, the black and white print was treated with thiocarbamide toner. The finished print looks very similar to the type of effect achieved with old-fashioned sepia toning, but the modern chemicals are easier to use and don't have the unpleasant odour associated with sepia toners.

From a strictly photographic point of view, subjects who opt to have their portraits taken in other than normal street clothes make, potentially, far more interesting pictures. And the more colourful or unusual the style of dress, the more eye-catching appeal it is likely to have. However, some caution is called for, since colour in portraiture can sometimes work against you by becoming the dominant feature of the photograph and pushing the subject into the background.

Formally commissioned portraits are, for the subject concerned at least, special events, since they happen only very occasionally. To maximize your chances of producing a photograph, or set of photographs, that clients will be happy with, suggest that they bring one or two changes of clothing with them to the studio, or at least a selection of different accessories. If you are shooting the pictures in the client's own home, then you will have the entire wardrobe from which to make a choice.

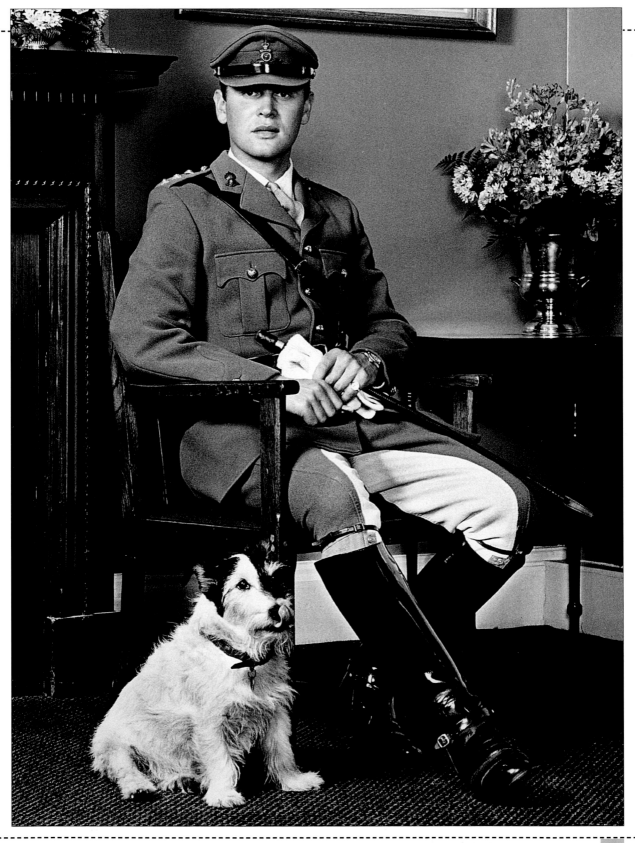

SHADOWLESS LIGHTING

irectional lighting (that is, light falling on your subject from predominantly one direction only) – with, perhaps, a reflector positioned on the opposite side to help lighten the shadows a little and thus hold contrast down overall – is one of the standard techniques employed to bring out such subject qualities of shape and form, as well as surface characteristics, such as texture. However, if you set up two lights positioned equidistant from the subject, one on either side of the camera, making sure that the power settings on both lights are identical, then the shadows cast by one light will be filled (and therefore largely neutralized) by the light from the other. The result is, as you can see here, a virtually shadow-free photograph.

PHOTOGRAPHER:
Simon Alexander

CAMERA:
6 x 6cm

LENS:
80mm

EXPOSURE:
⅟₃₀ second at f11

LIGHTING:
**Studio flash x 2
with translucent flash
umbrellas and reflector**

◀ *The subject was positioned 1½ metres (about 5ft) from the camera, and matched flash units fitted with translucent "shoot-through" flash umbrellas to diffuse and soften the light, were set up either side of the camera. A reflector just in front of the subject's lap picked up enough light to kill any shadows on her neck and the underside of her chin. The black background paper was 3 metres (about 10ft) behind the subject – far enough back not to pick up any overspill of light from the set.*

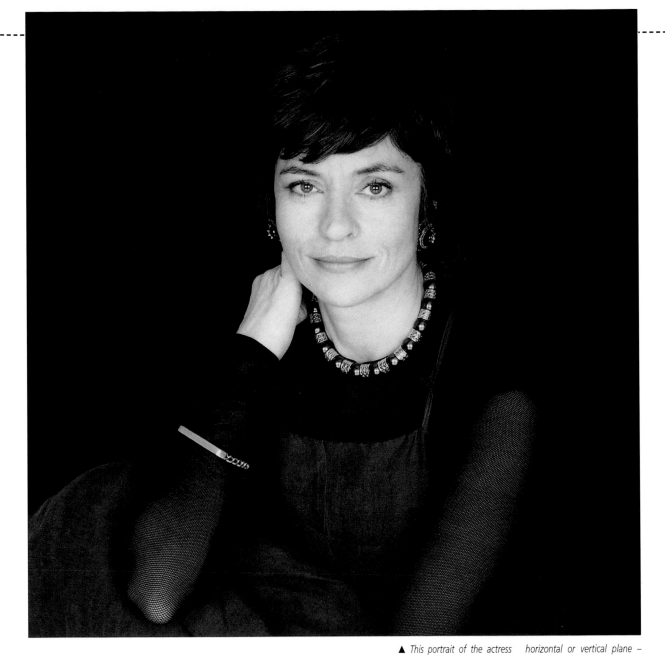

▲ This portrait of the actress Diana Quick was composed and lit to work on two levels. First, as a large print, the starkness of the lighting, with the subject's face glowing out of a featureless black background, has great impact. Note, too, that all the information is in the horizontal or vertical plane – there has been no attempt to imply the dimension of depth.

Second, when greatly reduced in size, the picture still has great presence on the page – a necessary attribute since this shot is used small in the casting directory Spotlight.

RELAXING THE SUBJECT

Unless you are working with a model or a celebrity, people usually look forward to being in front of the camera for a studio portrait session with some degree of apprehension. Not only are the surroundings strange and unfamiliar, but most people are more aware of their perceived physical shortcomings than their attributes, and thus feel vulnerable under the glare of the studio lights.

An important part of the photographer's task, therefore, is to put the subjects at ease, and one of the best ways of doing this is to engage them in conversation. If you know something about the people, either professionally or personally, before meeting them, conversation will be easier to generate. If not, then try to find out from your subjects something about their interests, hobbies, what they do at work, how they like to relax, and so on. If subjects have strongly held opinions about how they should best be photographed, and these don't correspond with what you want to achieve during the session, listen to their points of view, take some frames, and then start suggest slight changes that, bit by bit, bring them more around to your way of thinking.

Hints and tips

● As photographer, play the role of host in the studio. If the session is going to take some time, have some refreshments available.

● Some people relax more if they have some sort of prop to concentrate on. People not used to being in front of the camera often don't know what to do with their hands and so they may respond well if you give them something to hold.

▲ A single studio flash, fitted with a softbox, positioned immediately to the right and behind the camera position provided the only illumination for this portrait. Reflector boards on the opposite side of the subject were used to lighten shadows, and the subject was seated well in front of the background paper to ensure that he appears as a well-lit figure in a totally dark and featureless space.

PHOTOGRAPHER:
Robert Hallmann

CAMERA:
6 x 7cm

LENS:
80mm

EXPOSURE:
1/60 second at f8

LIGHTING:
Studio flash with softbox and reflectors

▶ A cup of tea offered to the subject during a pause in shooting helped to put the man at ease, and the resulting photograph of him, with cup still in hand, was the most successful shot of the session.

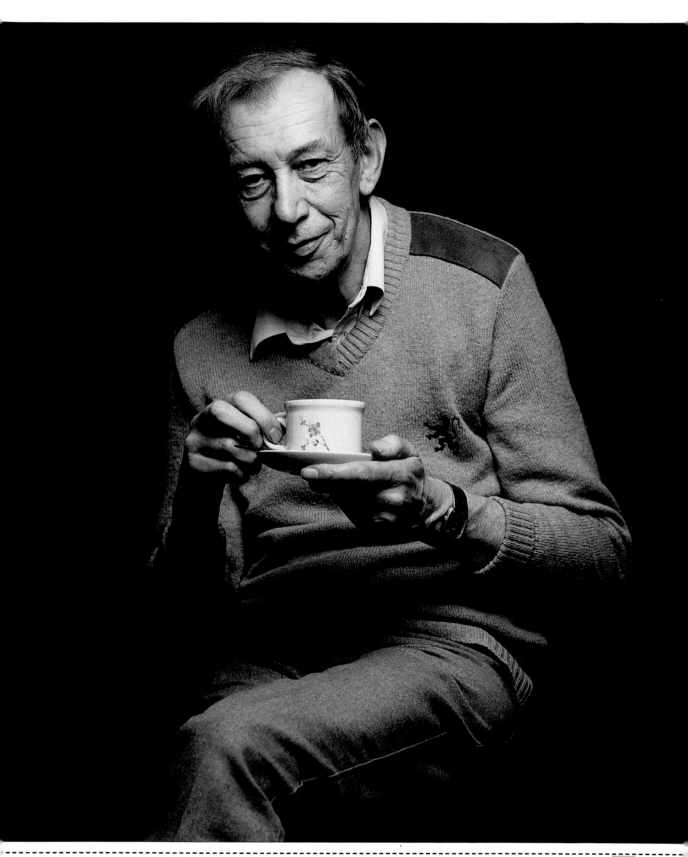

USING THE SETTING

Portraits often communicate better if subjects are photographed in settings that are relevant to their personal or professional lives. Not only does this give the viewer of the photograph some additional information about and insight into the person featured, you will probably find that your subject is more relaxed, too, and this greatly contributes to the success (or otherwise) of a session.

When working in the subject's home or office, however, you inevitably lose some of the control over lighting you would have had in the studio. If possible, visit the location for the session before the day of the shoot to see what natural light, if any, will be available, to see what space you will have to work in, and to determine the need for extension leads, background papers, filters, and so on.

▶ The glowering features of the publisher Lord Weidenfeld in his office. Consciously or otherwise, he has adopted a pose not dissimilar to the bust under which he is seated.

PHOTOGRAPHER:
Steve Pyke

CAMERA:
6 x 7cm

LENS:
65mm

EXPOSURE:
1/125 second at f11

LIGHTING:
Daylight, studio flash x 3, and reflector

◀ To supplement the background level of daylight, one flash unit was set just to the left of the camera position, but well above the subject's eyeline so that any cast shadows would be short. Other flash units were positioned to the left and right to light the floor-to-ceiling bookshelves, while a reflector low down in front of the subject bounced additional light upward, toward his face.

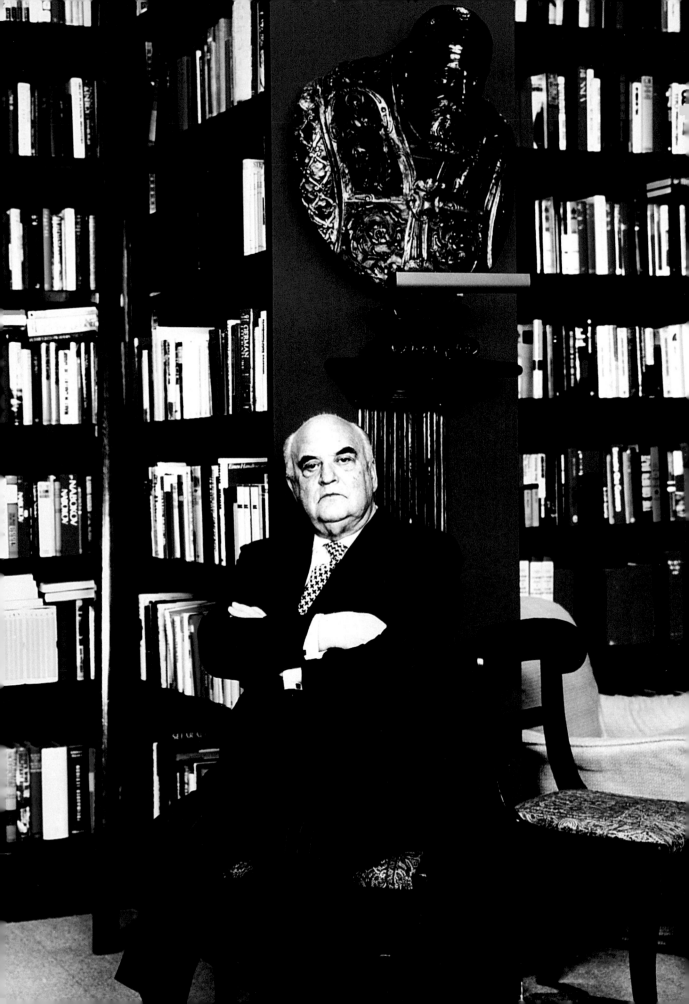

LAST PORTRAIT

The actress Dame Gwen Ffrangcon-Davies was 90 years old and almost blind when this photograph of her was taken. It was one of a series of pictures taken by the photographer, Nicholas Sinclair, of actors and actresses for an exhibition he was preparing for in 1992. At first, Dame Gwen refused Nicholas's request for a sitting. However, when she later heard that Alec Guinness, Paul Scofield, Wendy Hiller and Cyril Cusack had already sat for their portraits, she changed her mind saying: "I've decided that I want to be amongst my friends."

"Had I photographed her looking directly into the lens," writes Nicholas Sinclair, "the picture would have been very unflattering, given the fact that she was almost blind and had very thick glass in her spectacles. I therefore used a three-quarter view, turning my subject away from the light source but keeping enough contact with her eyes to express both her spirit and her inherent sense of tranquillity. I added the shawl because she complained of feeling cold during the sitting and, in fact, the shawl adds a strong circular feel to the composition."

PHOTOGRAPHER:
Nicholas Sinclair

CAMERA:
6 x 6cm

LENS:
150mm

EXPOSURE:
¹⁄₆₀ second at f5.6

LIGHTING:
Studio flash with softbox and reflector

EFFECTS:
Platinum print (see following page)

◀ One studio flash unit fitted with a softbox was positioned to the right of the camera and one large white reflector board on the opposite side, angled to reflect light back into the subject's face.

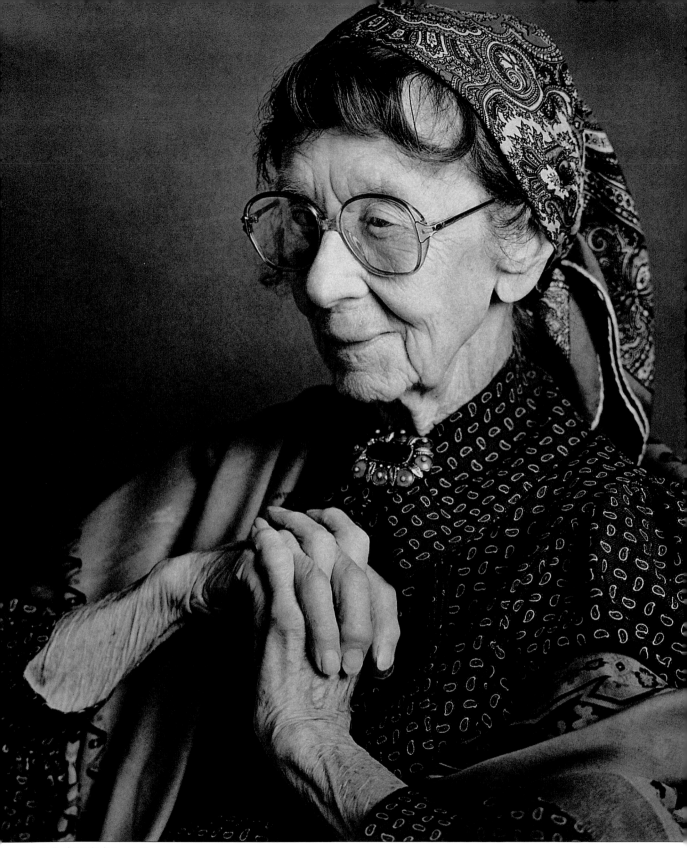

▲ *Sadly, this is the last portrait ever taken of Dame Gwen Ffrangcon-Davies. She died just a few months after the picture was taken.*

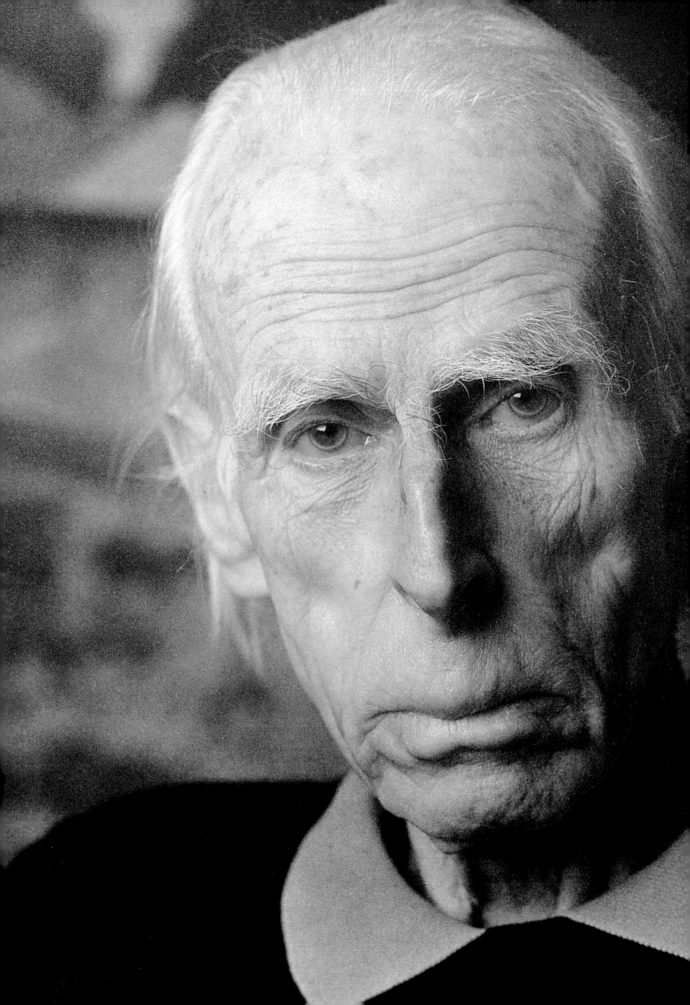

STRENGTH AND FRAGILITY

This portrait was taken in 1990 when the artist John Piper was 87 years old. In the photographer's words: "There was no motive for taking the photograph beyond the fact that he has an extraordinary face and has always been one of my favourite British landscape painters. He was a very modest and gentle man, frail after an illness, but his gaze into the lens is haunting. With such intensity in a face, my instinct is to move in close and let the subject's face dominate the frame."

PHOTOGRAPHER:
Nicholas Sinclair

CAMERA:
6 x 6cm

LENS:
**150mm with 16mm
extension tube**

EXPOSURE:
½₂₅ second at f4

LIGHTING:
**Daylight and studio flash
with softbox**

EFFECTS:
Platinum print

◀ *The simplicity of the composition and the absence of anything artificial or contrived in the picture make this a particularly powerful image of a face that expresses both a strength of purpose and the fragility of old age.*

The platinum print process

This photograph of John Piper, and the one on the preceding page of Dame Gwen Ffrangcon-Davies, are platinum prints made by Roy Gardner. This process was favoured at the end of the 19th century and combined platinum and iron salts to make a light-sensitive solution that was coated on a sheet of fine-quality paper. The platinum process used in these prints has been adapted to take advantage of contemporary materials. They were made by contact printing enlarged negatives onto watercolour paper that had been hand coated with an emulsion consisting of platinum and palladium metals. After drying, the paper was exposed under the negative to a strong ultraviolet light source. Development is in a bath of potassium oxalate after which the print is immersed in baths of hydrochloric acid before being washed. Each print can take as long as three days to complete and requires considerable skill, experience, and patience.

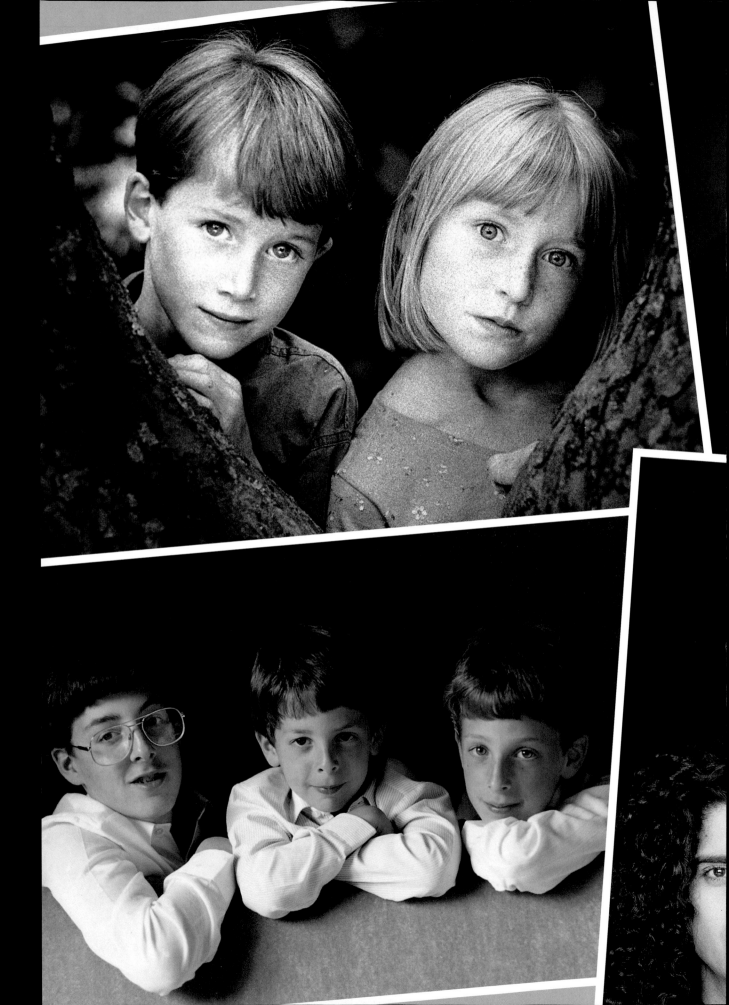

COUPLES AND GROUPS

STREET ENCOUNTERS

While it is true that nearly all portrait photographers earn their living by taking commissioned photographs of people who have contacted them specifically, there are some for whom portraiture holds such a fascination that at least part of their work is more speculative in nature. The subjects of these pictures may be the result of casual encounters, people the photographer has simply met in the street and asked to pose or has taken unawares, using more of a candid approach to the photography.

When we look at some portraits it is possible to see far more than just that person's physical appearance. Rather, the photographer has managed to get under the skin of the subject and provide us with at least some insight into that person's character. Good-quality portraits of this type do have a market, although it is not an easy one to break into. Some galleries, for example, specialize in mounting photographic exhibitions, while some more general art galleries hold periodic photographic exhibitions, where individual prints can be bought by collectors. The publishing world, too, is another outlet for work of this type – for use in books and magazines.

PHOTOGRAPHER:
Anthony Oliver

CAMERA:
6 x 6cm

LENS:
80mm

EXPOSURE:
⅟₆₀ second at f8

LIGHTING:
Daylight and flash

▶ *With his arm protectively around his partner's shoulders, a range of emotions can be read into the faces of this couple as they stare, with a goodly measure of distrust, into the camera's lens.*

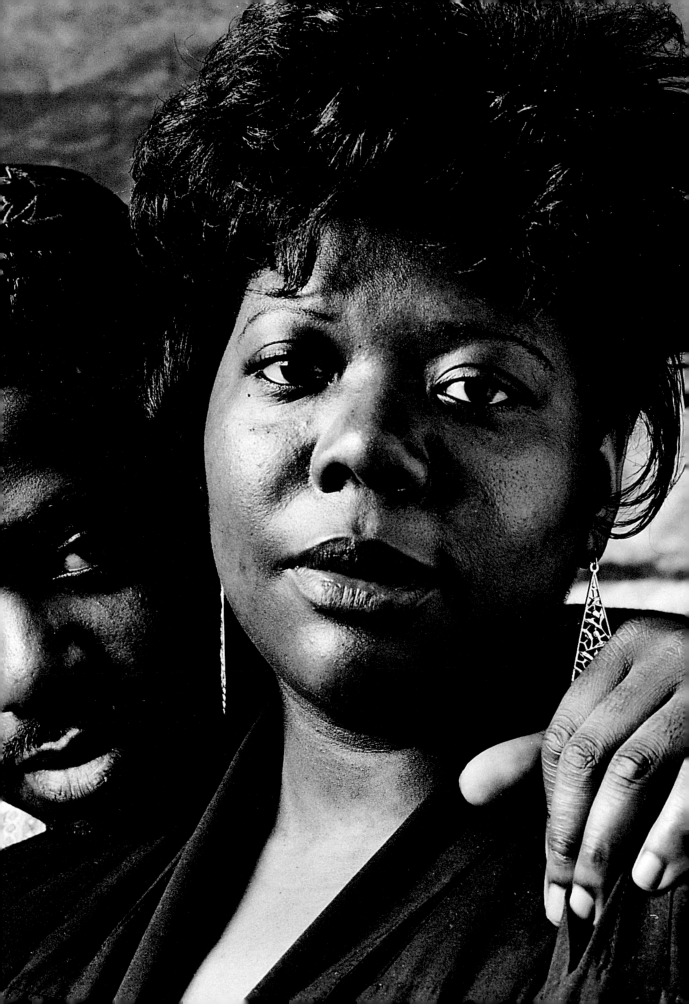

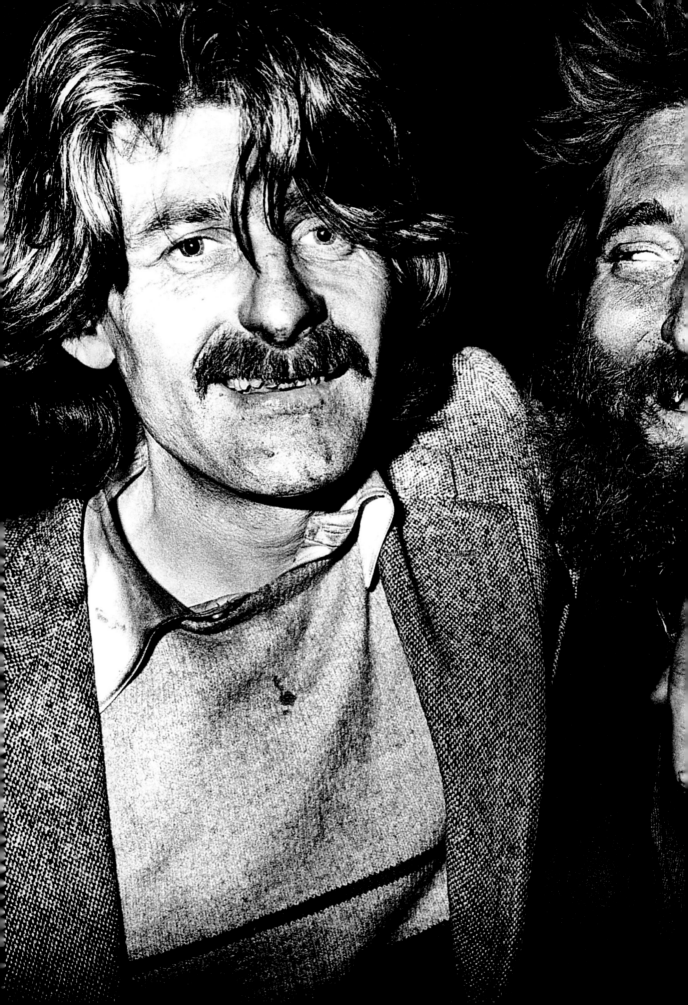

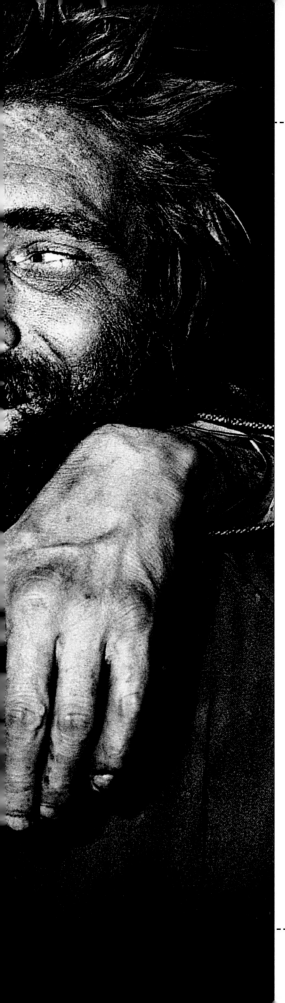

◀ *Two faces, lined and ingrained with dirt, with a history we can only begin to guess at. Although poor and homeless, their faces are still strong and their spirits appear unbroken.*

PHOTOGRAPHER:
Steven Pyke

CAMERA:
6 x 6cm

LENS:
100mm

EXPOSURE:
⅟₆₀ second at f11

LIGHTING:
Portable flash

▼ *The light from accessory flash is most often used bounced off a ceiling or wall to produce an indirect, more flattering type of effect. Outdoors, however, where reflecting surfaces are more difficult to find, flash can be used direct to give a gritty type of realism. A flash bracket such as the one illustrated here, lifts the flash unit well away from the camera lens and so virtually eliminates the problem of "red eye".*

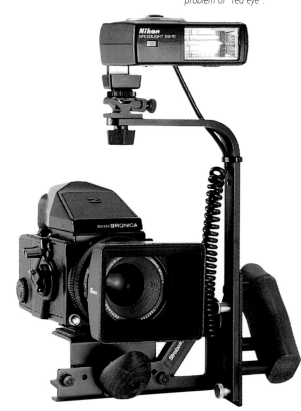

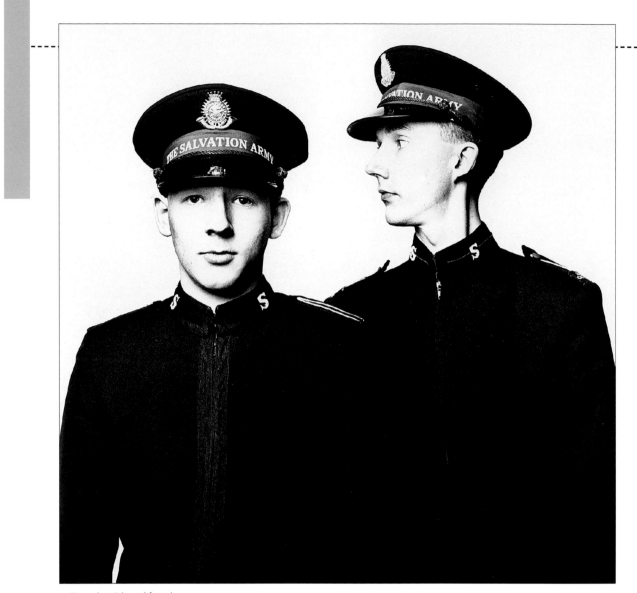

▲ Ramrod straight and formally posed, these two soldiers of the Salvation Army were photographed against a featureless backdrop to emphasize the restricted tonal range of which the image is composed.

PHOTOGRAPHER:
Steven Pyke

CAMERA:
6 x 6cm

LENS:
120mm

EXPOSURE:
¹⁄₃₀ second at f16

LIGHTING:
Studio flash x 2

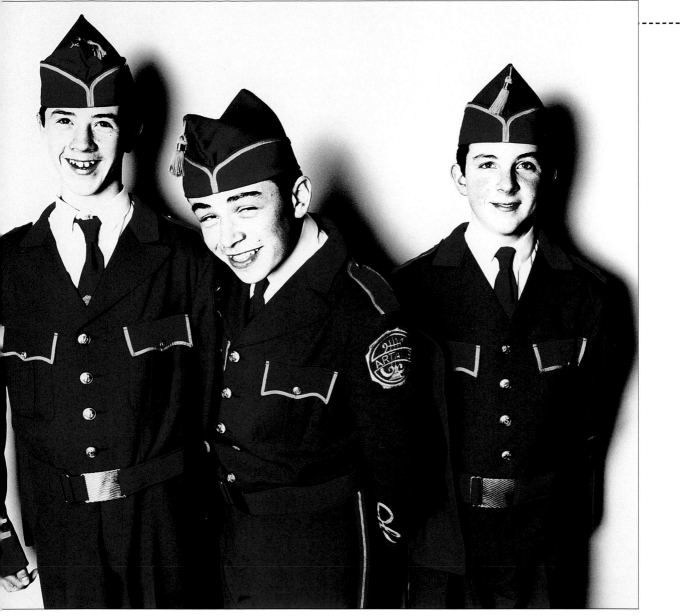

▲ A mixture of pride and ado-
lescent awkwardness can be
seen in this group portrait of
three boys following in the long
tradition of Irish marching
bands. The colour of their uni-
forms was already intense, but
it has been strengthened fur-
ther by processing the colour
transparency film in chemicals
designed for colour negatives.

PHOTOGRAPHER:
Steven Pyke

CAMERA:
6 x 6cm

LENS:
80mm

EXPOSURE:
⅟₆₀ second at f11

LIGHTING:
Studio flash x 2

COLOUR OR BLACK AND WHITE?

U nless you specialize in either the black and white medium or the colour medium, and clients commission you on that basis, then the choice of which type of film stock to use for a particular portrait session is something photographers and clients should discuss at the outset.

On some occasions, the argument for using one medium instead of the other is overwhelming. If, for example, the clients are a couple looking for a set of studio wedding shots, then the colour of the bridal gown and the bridal bouquet may be sufficiently important to make colour the obvious choice. Similarly, in a portrait of somebody with startlingly blue eyes or deep chestnut-red hair, these features will become less significant if shown in black and white. On the other hand, colour can be distracting in portraiture, with small areas of essentially irrelevant colour in the clothes, props, or set taking attention away from the face, form, or figure of the subject.

Keep your options open

As a commercial photographer, the most prudent and flexible approach to the subject of black and white or colour is to keep your options open. By shooting in colour transparency film, you then have the choice of producing:

● A slide for projection

● A colour print

● A black and white print

● A black and white transparency

Some of these conversion processes do require copying the original image, however, so you must expect some loss of picture quality. Bear in mind that any after-treatments will inevitably add to the costs to the client.

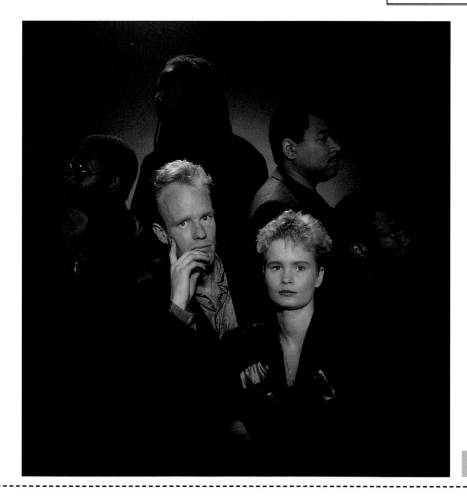

PHOTOGRAPHER:
Jos Sprangers

CAMERA:
6 x 4.5cm

LENS:
70mm

EXPOSURE:
⅕ second at f16

LIGHTING:
Studio flash x 4

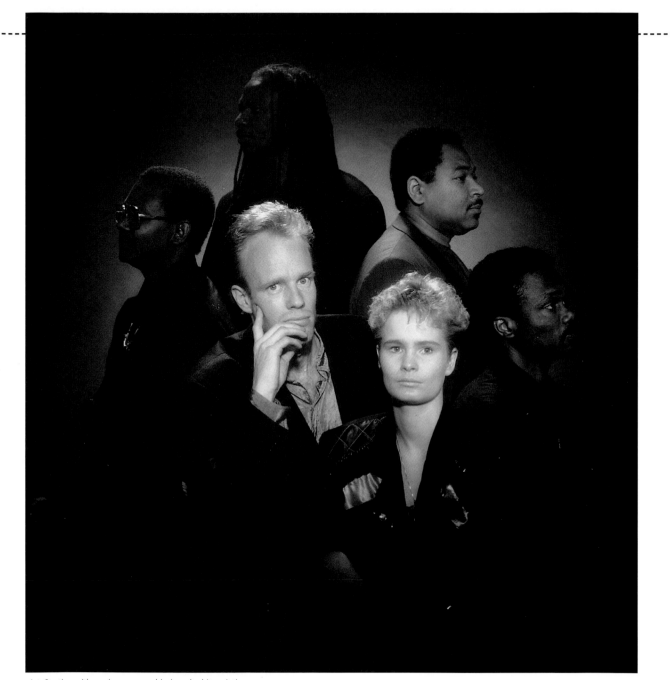

◄▲ Starting with a colour negative original, the photographer produced both colour and black and white prints. The colour version shows a well-composed, well-lit group portrait, with all subject detail crisp and clearly defined. The black and white version is slightly softer in comparison – black and white printing paper is not designed for the different layers of emulsion of a colour negative – but the areas of gold detailing on the woman's dress, the blue shirt of the foreground man, and the red T-shirt of the background figure are not nearly as prominent and are, therefore, less distracting.

DAYLIGHT EFFECTS

The principal advantage of using artificial studio lighting – either tungsten or flash – is that it offers the portrait photographer consistent, and therefore predictable, results. There is, however, a quality to natural daylight that makes it the preferred light source for many photographers.

The fact is that daylight is anything but consistent or predictable. Early morning daylight, when the sun is low in the sky, tends to be soft and warm-coloured. As the morning progresses and the sun moves higher in the sky, its light often becomes harder, shadows become better defined, and its colour

more blue in content. Then, as the sun moves back down toward the horizon once more in the afternoon, its lighting quality changes yet again – shadows lengthen and its colour content shifts more toward the yellow and red end of the spectrum.

It is not only the time of day, however, that affects the quality of daylight. Other factors, such as the weather or the changing seasons, also have a tremendous impact.

However, it is these many different moods and qualities of daylight that are so favoured by dedicated daylight portrait photographers.

▶ Daylight is capable of producing all manner of lighting effects, from soft and even to contrasty and uncompromising. The light levels on the subjects' faces in this portrait were so high that an aperture/shutter speed combination could be set that rendered the shadowy background completely black.

PHOTOGRAPHER:
Majken Kruse

CAMERA:
35mm

LENS:
90mm

EXPOSURE:
½₅₀ second at f11

LIGHTING:
Daylight only

◀ Indirect daylight from an open, bright sky entered the studio through windows that had been masked down with black-out material to produce this spotlight effect.

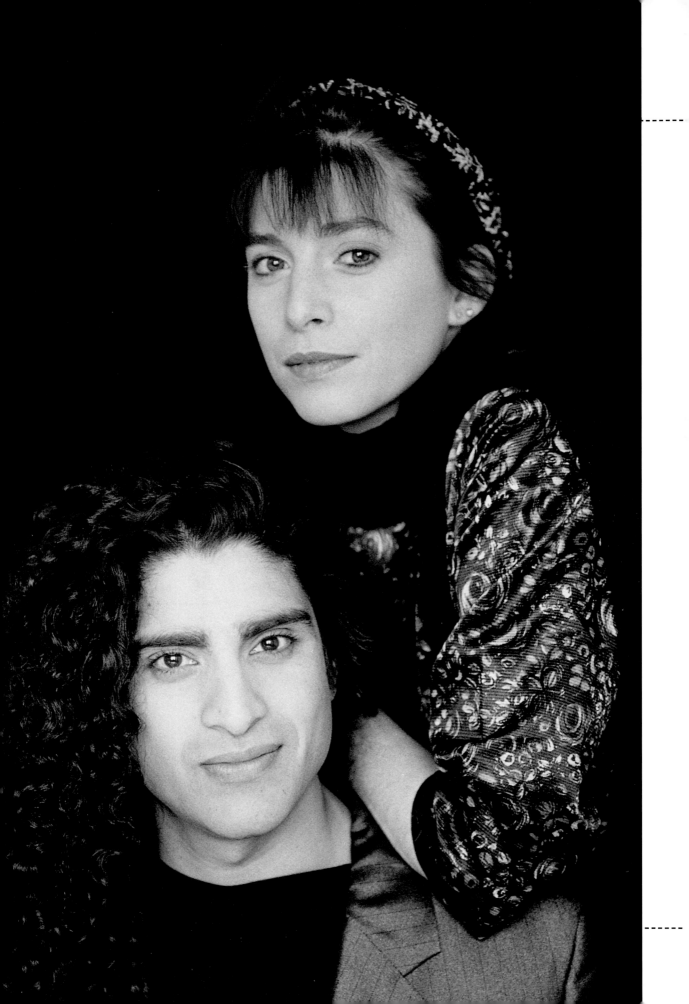

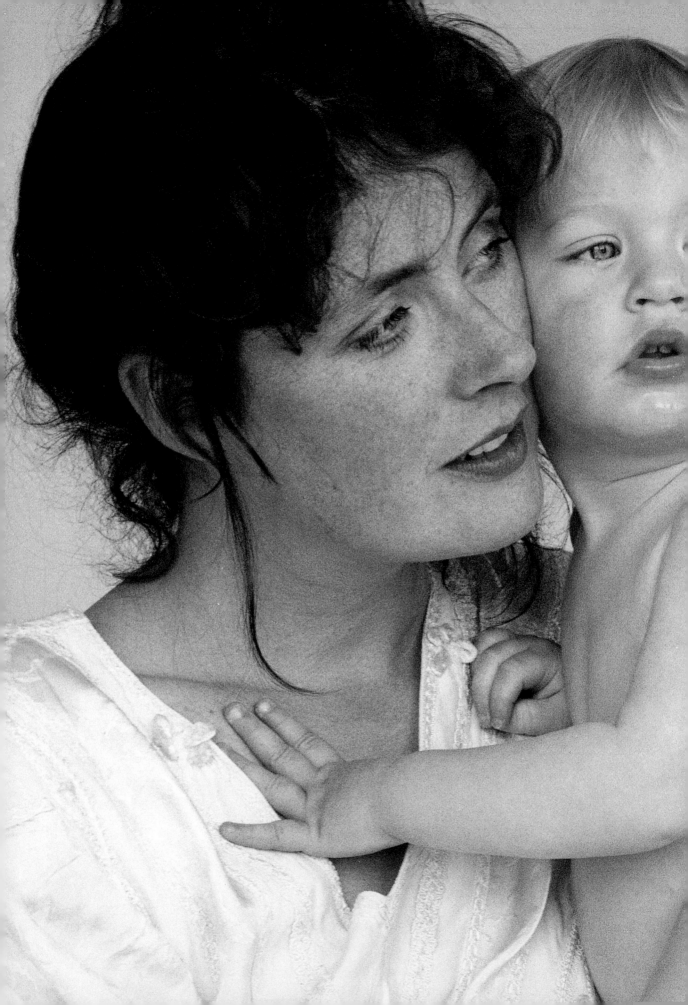

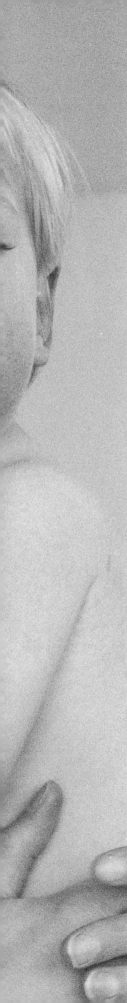

◄ *When an infant is involved, it is sometimes better to conduct a portrait session in the client's own home. The travelling involved, as well as the strange surroundings of a studio, can be very unsettling.*

PHOTOGRAPHER:
Majken Kruse

CAMERA:
35mm

LENS:
28-70mm zoom

EXPOSURE:
$\frac{1}{125}$ second at f11

LIGHTING:
Daylight only

Hints and tips

● When using colour film, daylight and flash can be mixed in the same shot without problems of colour casts.

● A daylight studio with windows facing north (in the northern hemisphere) gives a more even, indirect light than a studio with windows facing south, which tend to catch more of the direct rays of the sun.

● Daylight entering through small windows tends to be harsher and more contrasty than light entering through large windows.

● Use large sheets of tracing paper, net curtains, or other translucent material over the glass of windows to diffuse and soften the light.

● Daylight from an open blue sky tends to have a cold blue cast and you may have to use a warm-up filter over the lens to counteract it.

● Exposure readings can fluctuate very quickly when using daylight, so make sure to take a light reading just before pressing the shutter release.

● Provide a few toys and games for older children to play within the studio to stop them becoming bored while they wait for their turn in front of the lights.

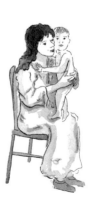

▲ *French doors and large windows provided masses of indirect light for this portrait. Hand-holding the camera gives the photographer more flexibility and mobility.*

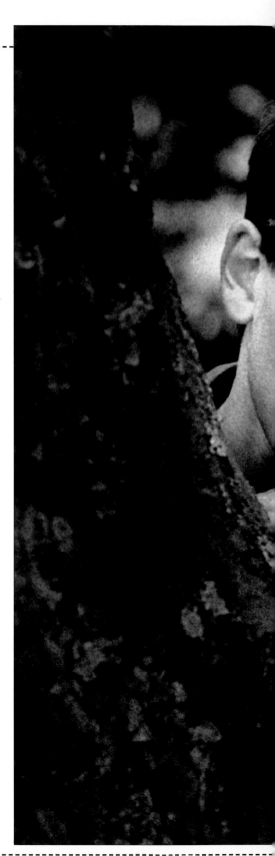

▶ *A bright, overcast sky provided the main lighting for this double portrait, taken just outside the photographer's studio. The only other light used was supplied by a silver-coloured reflector, angled to bounce a little extra light into the faces of the children.*

PHOTOGRAPHER:
Nigel Harper

CAMERA:
35mm

LENS:
135mm

EXPOSURE:
⅟₆₀ second at f5.6

LIGHTING:
Daylight and reflector

▲ *Small portable reflectors are useful outdoors to fill shadows and even out contrast.*

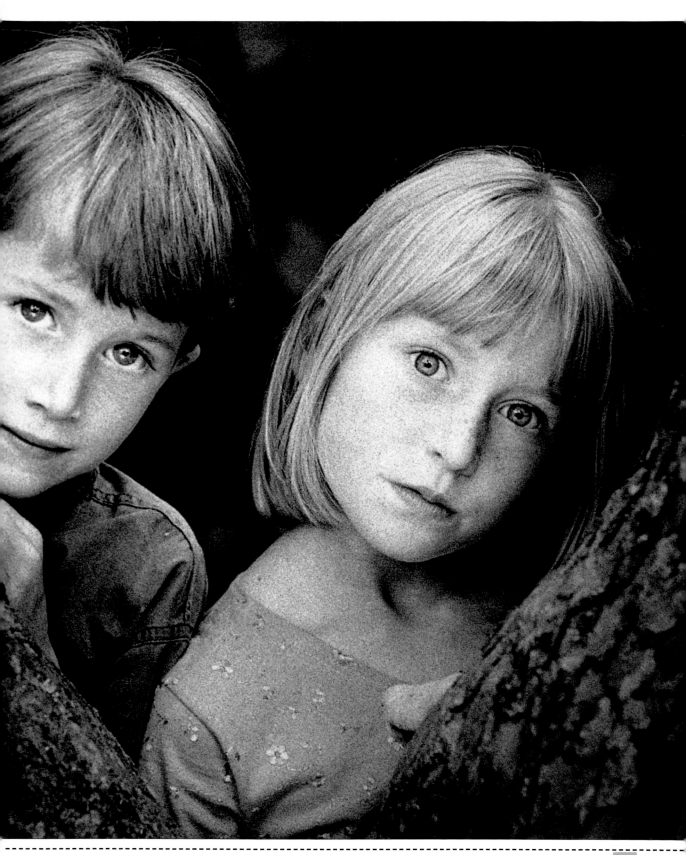

LIGHTING VARIATIONS

As the number of subject elements increases so the potential technical and aesthetic problems tend to multiply, especially if you want to achieve very precise results. All the considerations to do with relaxing the subjects and getting them in the right frame of mind to project their personality in front of the camera still exist, but when you are photographing couples and groups you need to bring everybody to the right pitch at exactly the same time.

The principal lighting problem with couples and groups is ensuring that shadows from one person are not cast over visually important parts of another person in the group. This is of particular concern when you are using directional lighting, either to the left or right of the subjects, as the main illumination, and less of a problem if you employ predominantly frontal lighting and pose all your subject in approximately the same plane.

Another lighting technique often used is toplighting. When the light is positioned above the level of the subjects, shadows will be cast downward where they usually don't represent a problem. However, you need to watch out for unattractive shadows from the nose being thrown down over the mouth and chin and, if necessary,

counter these with some additional frontal light. In all cases, shadows are less hard-edged and, therefore, less pronounced if the light is reflected or diffused before it reaches the subjects.

Because of the need to monitor the effects of lighting so closely, continuous light sources, such as tungsten light and, of course, natural daylight, are often easier to work with than flash. Flash produces such a short-lived burst of light it is impossible to preview results. Professional studio flash units are often equipped with built-in modelling lights that indicate where the highlights and shadows will fall, and these do help considerably.

◀ *To light this group satisfactorily, each face needed its own light source. The lights were positioned the same distance from each person and each light was set to give the same output. Balancing the lights in this way is important so that any shadows cast by one light are filled in and, therefore, counteracted by the output from another. Out of sight of the camera behind the group, another light was used to illuminate the background paper.*

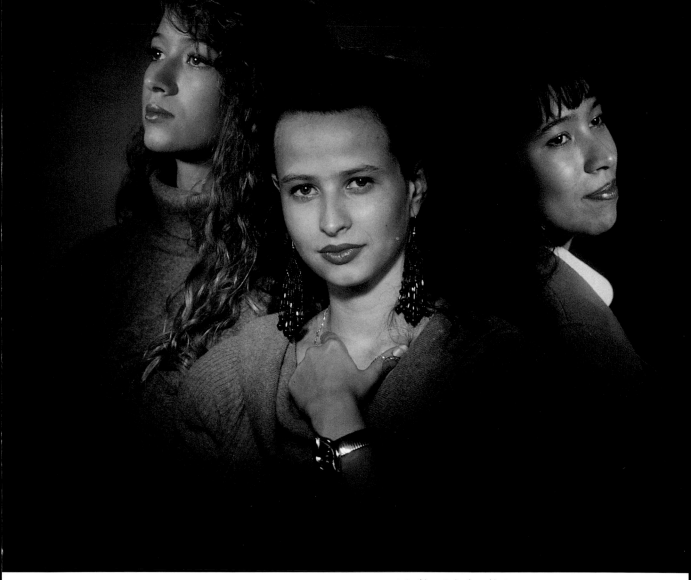

▲ In this portrait, the subjects are back to back and their faces are not all in the same plane, so lights need to be carefully set. Note the catchlights in each of the subject's eyes – although they are only tiny points of brightness, they bring the women's faces alive. In the darkroom, the edges of the printing paper were vignetted to create a darker tone.

PHOTOGRAPHER:
Jos Sprangers
CAMERA:
6 x 4.5cm
LENS:
80mm
EXPOSURE:
⅟₆₀ second at f8
LIGHTING:
Studio flash x 4

▲ A studio flash fitted with a large softbox to the left of the camera provided the main illumination for this portrait. A secondary flash, positioned much further back, and also fitted with a softbox, provided fill-in lighting to the right of the camera, while a third light, low down behind the girls, produced a halo of light on the wall behind them.

PHOTOGRAPHER:
Gary Italiaander
CAMERA:
6 x 7cm
LENS:
80mm
EXPOSURE:
⅙₀ second at f8
LIGHTING:
**Studio flash x 3,
2 with softboxes**

▶ Head to head, both dressed in basic black, and with their dark hair framing their faces, these two sisters make an attractive double portrait. Unless the photographer stays alert to potential problems, parts of the anatomy, such as the hand, may look very awkward in the final photograph.

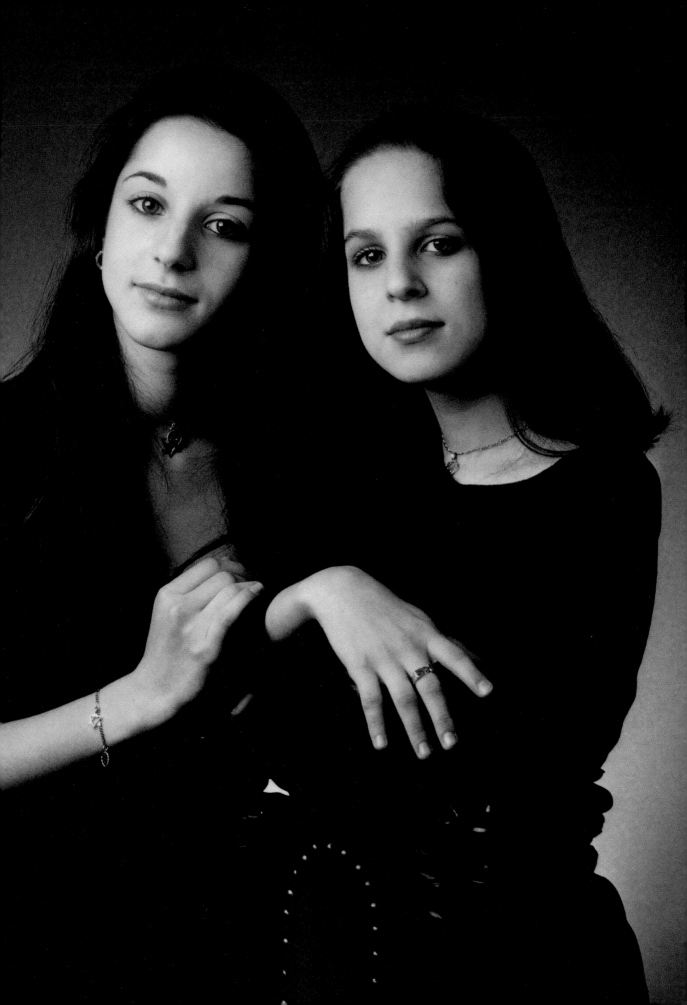

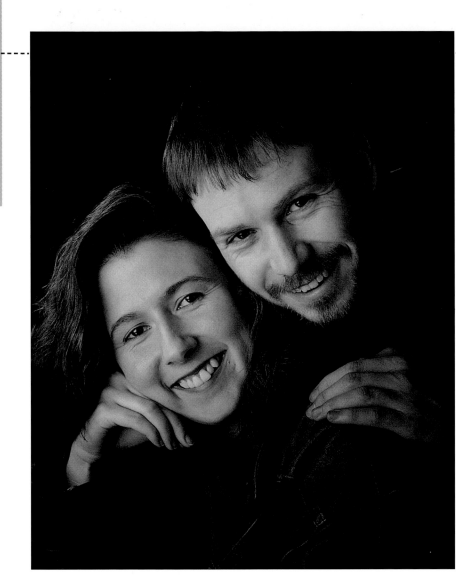

◄ A good relationship between photographer and subjects is evident in this double portrait, in which the subjects look happy and relaxed and seem to be thoroughly enjoying their time in front of the camera.

PHOTOGRAPHER:
Nigel Harper
CAMERA:
6 x 4.5cm
LENS:
120mm
EXPOSURE:
⅛₂₅ second at f16
LIGHTING:
**Studio flash x 5,
1 with softbox**

◄ Two lights to the left of the camera provided the main illumination for this photograph. The first, just to the left, was fitted with a softbox to give overall, generalized illumination. The other, which was set to a lower output and was slightly more directional, had no diffuser and has produced the brighter highlights you can see. High up and just behind the subjects, a third light provided additional illumination, while fourth and fifth lights behind the subjects provided rim and background lighting.

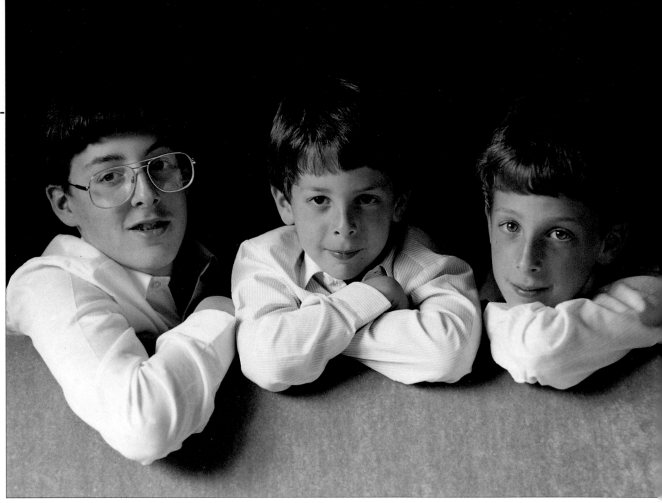

▲ By arranging all the members of this trio in the same plane, and then employing a mixture of toplighting, diffused three-quarter lighting, and reflectors, this group portrait has managed effectively to capture the boys' impish expressions.

PHOTOGRAPHER:
Gary Italiaander

CAMERA:
6 x 7cm

LENS:
80mm

EXPOSURE:
¹⁄₆₀ second at f16

LIGHTING:
Studio flash x 2, 1 with softbox, and reflectors

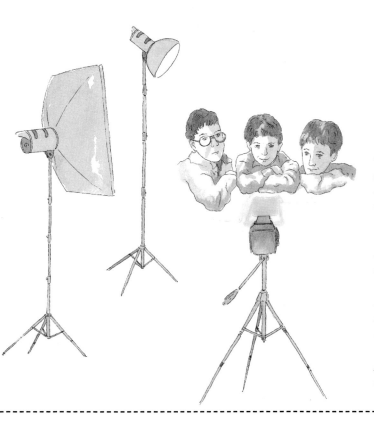

◀ An additional problem with setting the lights for this group portrait was ensuring that the spectacles of the boy on the left didn't reflect a "hot spot" back toward the camera lens. The toplighting is evident in the slight shadows under the folded arms of the subjects, while the principal light came from a studio flash fitted with a softbox to the left of the camera. Reflector boards to the right of the camera, close in to the subjects, reflected back sufficient light to relieve most of the facial shadows.

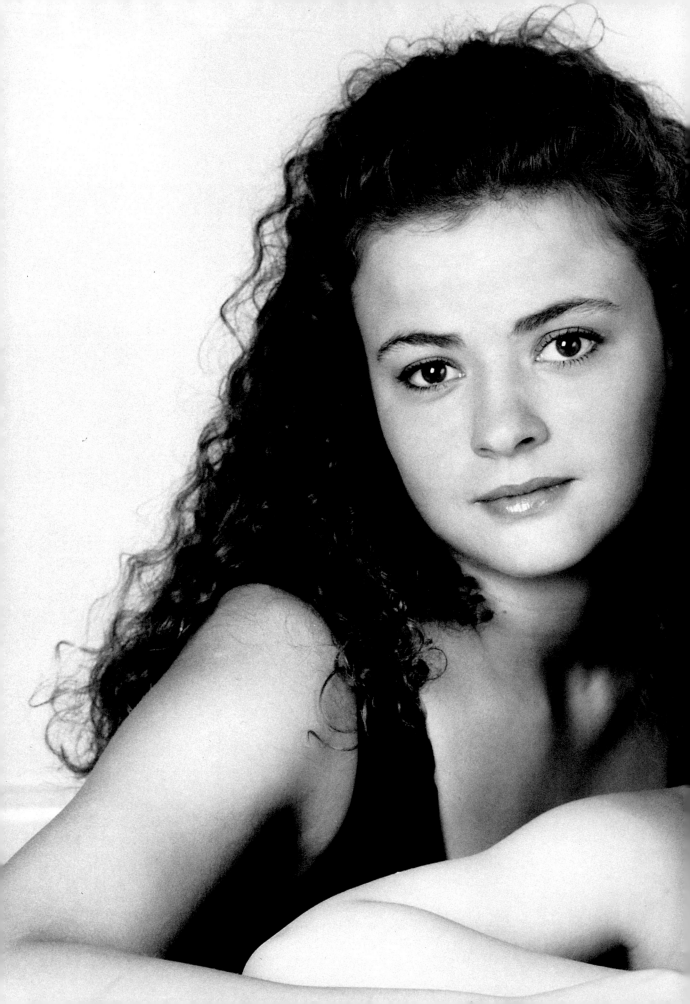

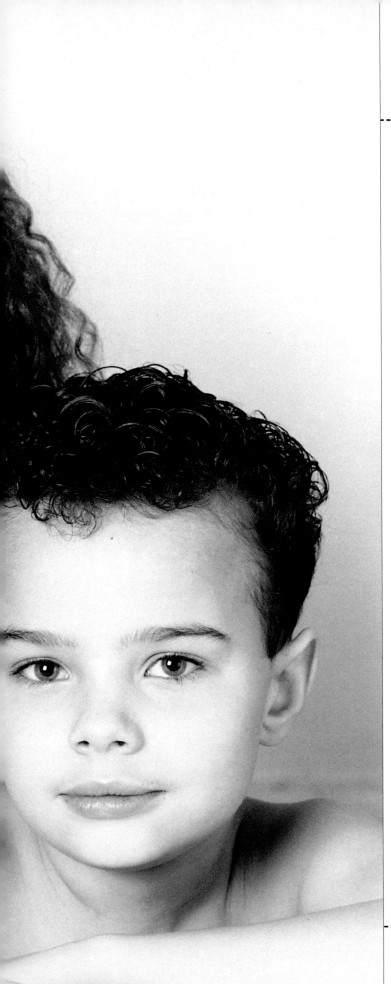

◀ The very simple lighting employed by the photographer accentuates the striking good looks of this brother and sister.

PHOTOGRAPHER:
Majken Kruse

CAMERA:
6 x 7cm

LENS:
120mm

EXPOSURE:
⅛₀ second at f22

LIGHTING:
**Studio flash x 2,
1 with softbox,
and reflectors**

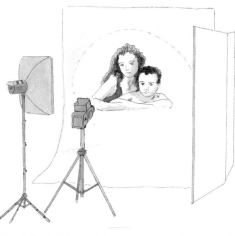

▲ The only frontal lighting used in this set-up was a studio flash fitted with a softbox just to the left of the camera. Large reflectors on the right of the camera produced an enclosed area, returning most of the light and ensuring that illumination was almost equal on both sides of the subjects' faces. Behind the subjects, well out of sight of the camera, another light was directed at the background paper to produce the stark white tone that outlines and defines their hair.

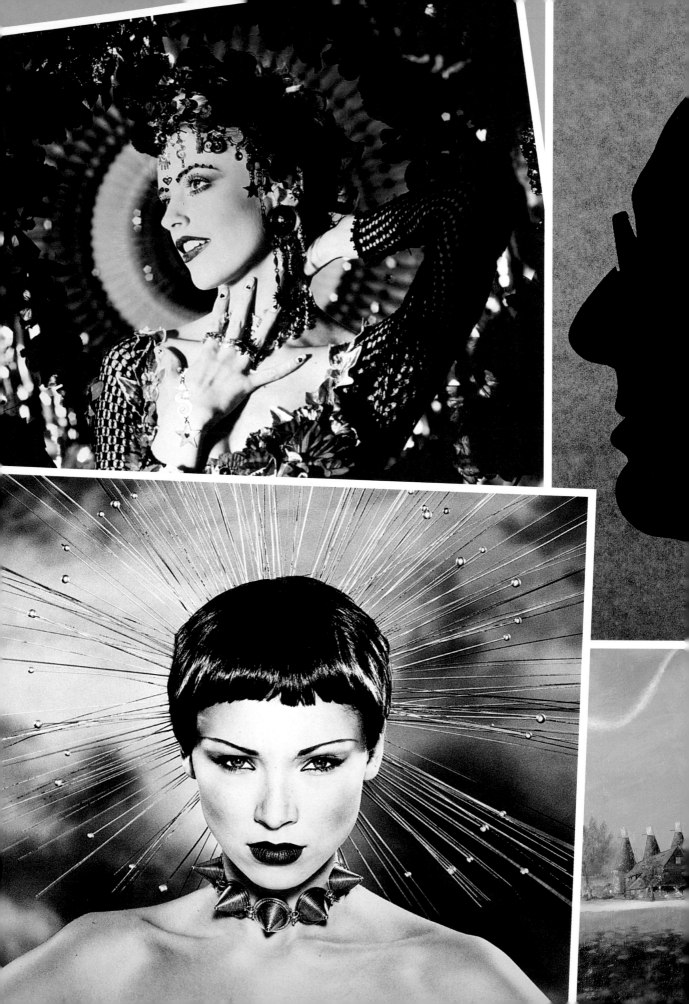

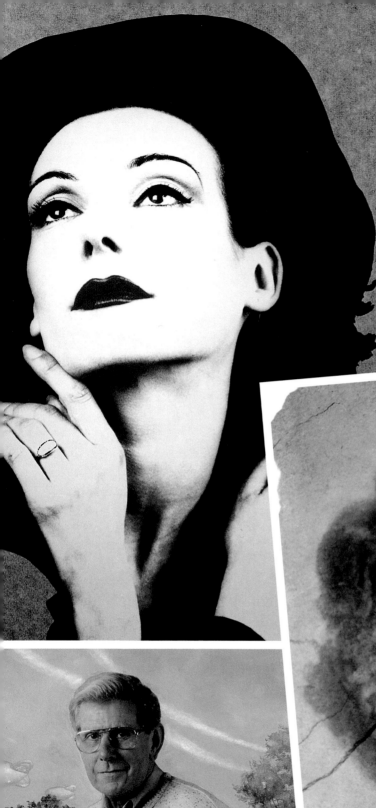

SPECIAL EFFECTS

RESTRAINED EFFECTS

When combining portraiture with special effects, often it is best to show some restraint in the techniques you employ, otherwise the emphasis of the image may shift too far away from the original intention. It is all too easy for special effects to have such visual impact that they end up swamping the subject.

The techniques used in the photograph illustrated here are a good example of how relatively small changes in the appearance of the subject can produce eye-catching, and quite intriguing, results. Apart from normal facial make-up, the subject was photographed completely "straight". The crown of silver-coloured antennae, once constructed, proved to be too heavy to be supported comfortably on the subject's head, so it was propped up in position on the end of a broom handle (what the eye doesn't see . . .). The backdrop is a large, painted canvas of a skyscape, which was rendered sufficiently out of focus by limiting the depth of field not to require too much attention to detail. After processing, the resulting print was then gold toned, and the toned print rephotographed to produce a large-format transparency for projection.

▶ *Although the only special effect employed in producing this print is a gold-toning process, this – combined with cleverly applied facial make-up, a futuristic headdress, and a painted backdrop – has created a portrait with eye-catching appeal. The framing of the subject's face was largely dictated by the height and spread of the headdress she is wearing.*

PHOTOGRAPHER:
Mann and Man

CAMERA:
6 x 9cm

LENS:
120mm

EXPOSURE:
$\frac{1}{125}$ second at f5.6

LIGHTING:
Studio flash x 2

◀ *A single studio flash with a wide reflector was used to frontally light the subject and backdrop, while a second light placed behind the subject was used to backlight her and help produce a distinct edge around her head and shoulders. This created the necessary separation between the subject and background canvas.*

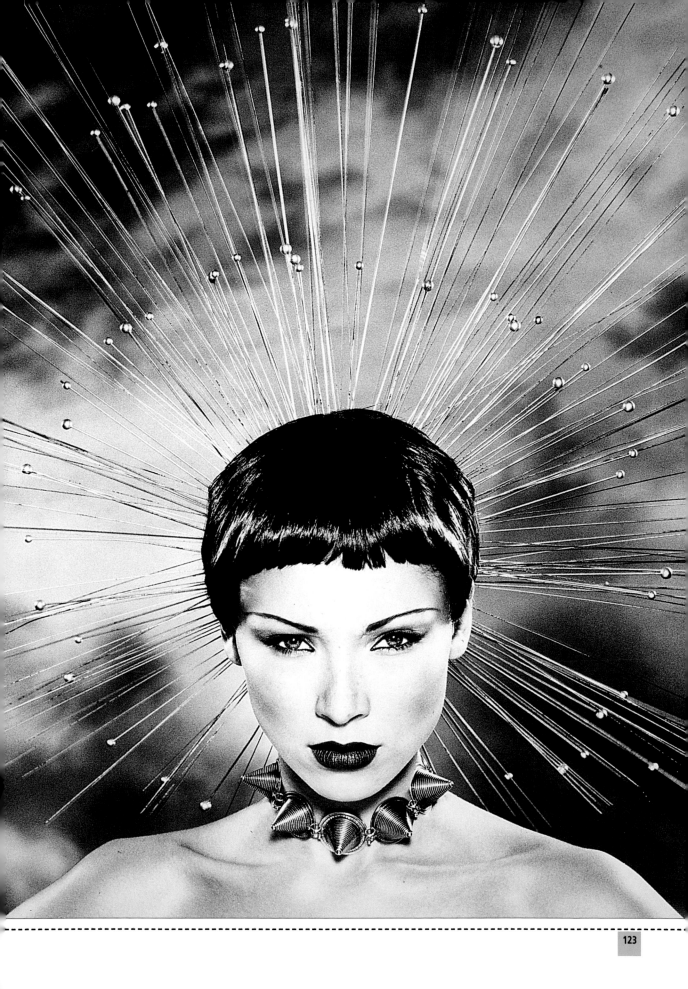

PAINTED EFFECTS

One special effect that has much potential appeal is a mixed-media technique involving photography combined with painting. The first stage of the process involves a traditional photographic session. Several portraits of the client are taken and, after processing, the best, or most appropriate, is selected.

Next, the client describes the type of setting he or she would like to see the portrait photograph combined with. It may, for example, be a particular landscape that was important in the person's childhood, or it could be a room setting or even a fantasy world inspired by literature. The client may be able to supply a photograph of the landscape or room, or an illustration from a book or magazine.

Once the rough for the background has been agreed, the original photographic image is reproduced onto canvas and the background scene is added using traditional oil paints. The complete work is then varnished and framed ready for hanging.

PHOTOGRAPHER:
Gary Italiaander
PAINTER:
Michael Italiaander

▶ *Combining photography with oil painting to produce a portrait with a distinctive style.*

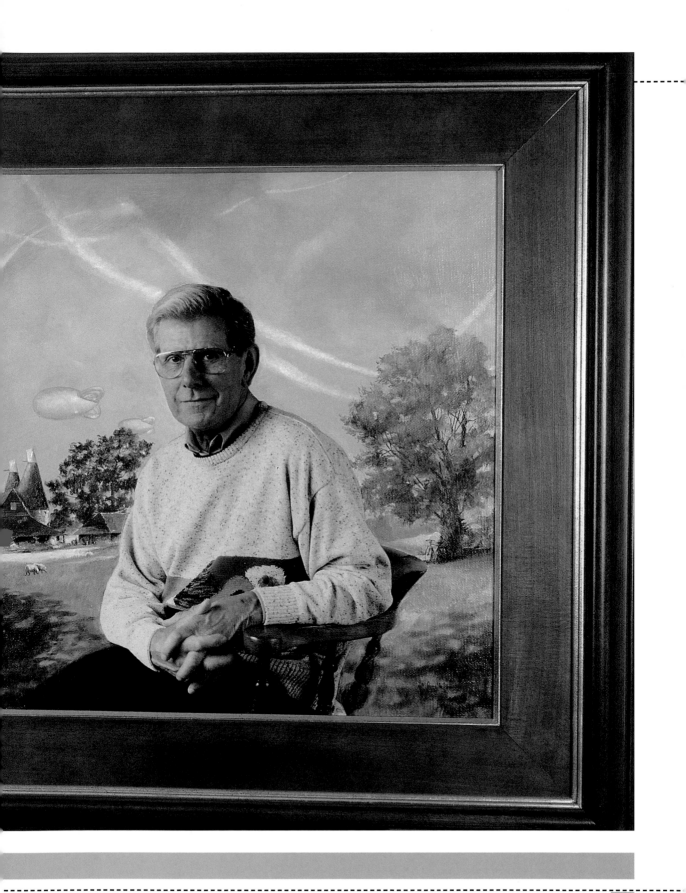

COMBINING IMAGES

Bizarre juxtapositions of subject matter and subject scale are possible using a technique known as sandwich printing. This darkroom process involves printing two film images simultaneously onto the same piece of printing paper.

If you look at a negative you will see that it shows image densities as being reversed from those of the original subject – in other words, where the shadows of the original subject fell, the negative appears as clear film, and where the subject details were, the film shows varying degrees of density. So,

by aligning the image details of one negative with the shadow area of another, you can produce a print of them both on the same piece of paper.

As well as using negatives, this technique also works with pairs of colour transparencies, although you will then have to print onto positive/positive paper (paper that produces a positive print from a positive original). Both colour and black and white negatives are suitable for sandwich printing onto negative/positive paper, or you could mix colour and black and white in the same print.

Using a light box, or any other convenient light source, select images that could work well together. If looking at 35mm slides or negatives, you may need to use a magnifying glass. Images that are too dense will not print when combined.

Once you have selected your images, placing them over each other to see that both subjects work together, carefully align both in the enlarger's negative carrier. Use tape, if necessary, to stop them shifting, but only on the film edges, or rebates.

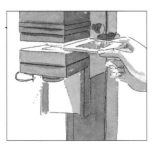

Load the negative carrier into the enlarger, turn off the room lights, and switch the enlarger on. Check the combined image projected down onto the baseboard to see if you are happy with the results. If, so, make a test print to gauge exposure.

PHOTOGRAPHER:
Steve Pyke

CAMERA:
6 x 7cm

LENS:
180mm (silhouette)
90mm (detailed face)

EXPOSURE:
1/60 second at f11

EFFECT:
Sandwich printing

▶ *By carefully aligning the silhouetted profile of one subject, which was an area of clear film on the original negative, with the fully detailed face of the other subject, a combination print of the two was made on the same piece of paper.*

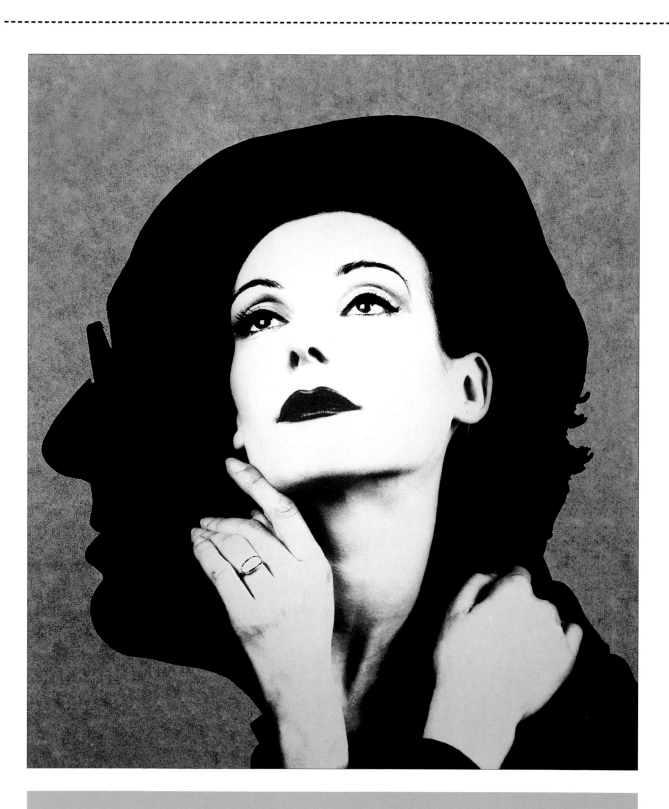

PROJECTION EFFECTS

Some special effects owe as much to the skills of the set builder as they do to any particularly sophisticated camera or darkroom techniques. The first step in creating this "multilayered" portrait was to stick a large, round paper fan to a studio flat and then position the subject in front of it. Next, a framework was built in front of the subject to support more studio flats decorated with paper flowers, tinsel, and coloured paper, leaving a large "porthole" through which the subject could be photographed.

After developing, drying, and mounting, the resulting transparency was projected onto a screen.

At this stage, further embellishments were added by sticking them directly to the screen holding the projected image. For example, extra flowers were added to the periphery of the image, and heart-decorated pins to the woman's eyebrows. As well, tiny beads were stuck to the ends of each projected eyelash. Once complete, the whole image was rephotographed onto transparency film.

▶ The predominantly fiery red coloration of the image and the proliferation of heart motifs would make this an ideal Valentine's Day portrait.

PHOTOGRAPHER:
Mann and Man

CAMERA:
6 x 9cm

LENS:
100mm

EXPOSURE:
**⅕ second at f22 (original image)
⅟₆₀ second at f11 (projected image)**

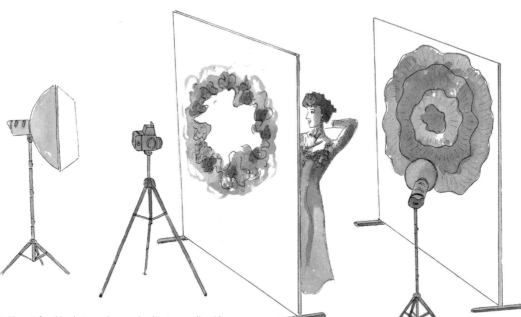

▲ The set for this photograph was a "sandwich" consisting of a fan-decorated background flat and flower-strewn foreground flats, with the subject in the middle. The foreground and subject were lit with one studio flash and softbox from the camera position, while the background was lit by another flash behind the subject out of view of the camera.

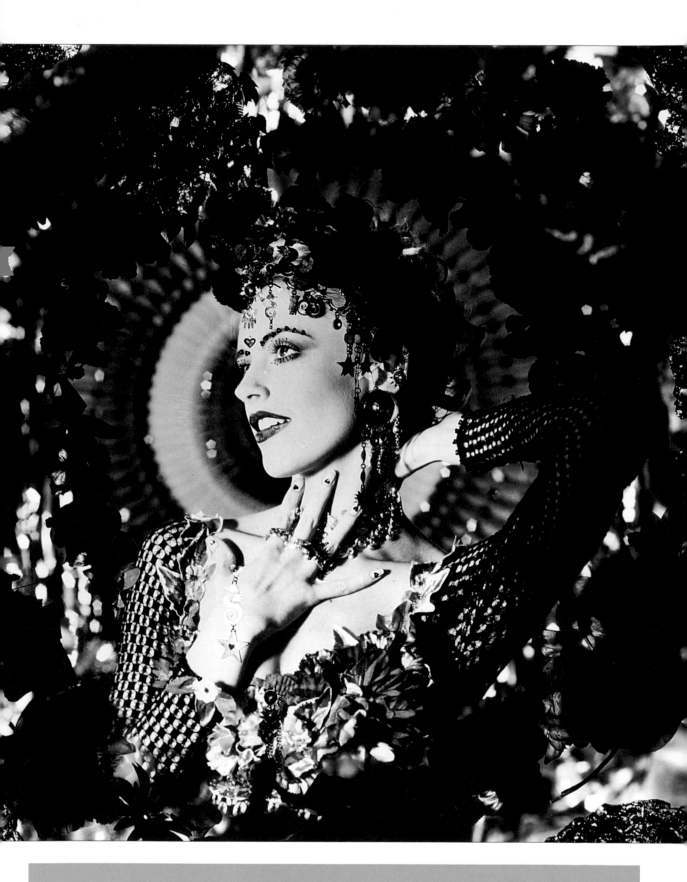

EMULSION STRIPPING

Some specialized film emulsions are made on a special gelatin base that can be dissolved in warm water, leaving the image-carrying part of the film to float free. The tissue-thin membrane of film carrying the image can then be manipulated before being floated back onto another supporting surface and stuck in place with special adhesive. This technique leaves the image open to all manner of interesting distortions, depending on the degree of treatment it receives. Bear in mind, however, that this technique is experimental and therefore results are highly unpredictable and often not repeatable.

▶ *To achieve this effect, the thin membrane of emulsion carrying the subject's image was floated off the film original, distorted to produce the cracks, wrinkles, and fissures you can see, and then carefully laid onto a piece of good-quality art paper. It was then photographed to produce a print that could be hand coloured before being rephotographed once more.*

PHOTOGRAPHER:
Jos Sprangers

CAMERA:
6 x 7cm

LENS:
120mm

EFFECT:
Emulsion stripping and hand colouring

Alternative technique

Another way of achieving a result similar to the one shown here is to sandwich two thin (overexposed) slides together in the same slide mount, project them, and then rephotograph the result from the screen. Normally exposed or underexposed images are too dense and will not allow sufficient light from the projector through both layers of emulsion for a bright enough image.

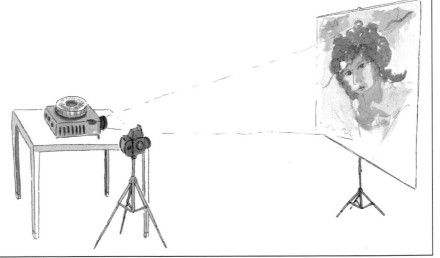

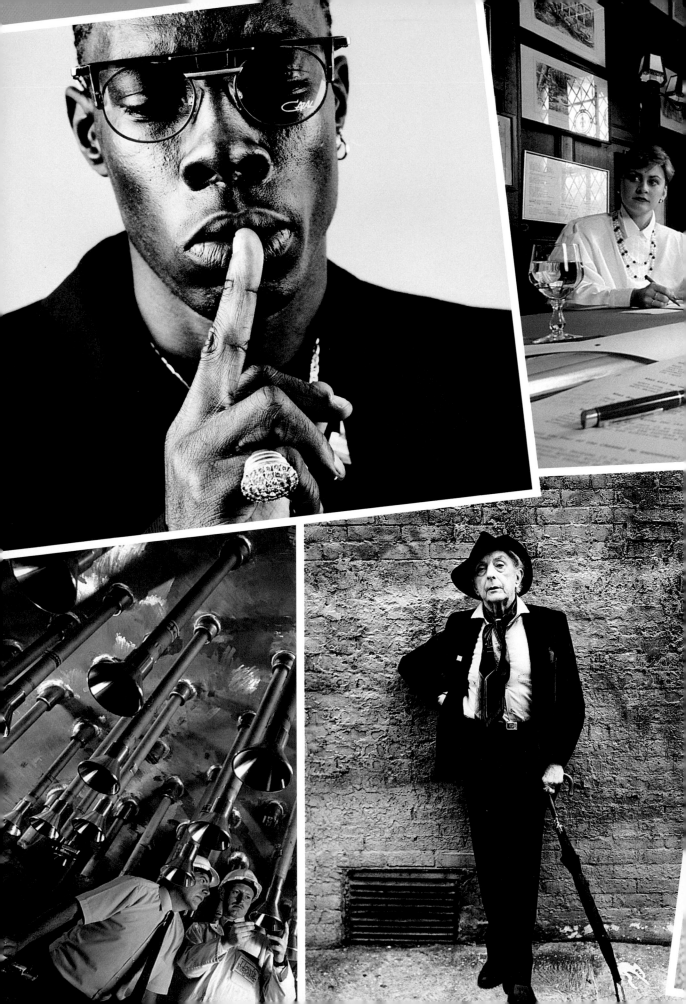

PORTFOLIOS

STRAT MASTDRIS

Corporate portraiture is always commissioned and never done on a speculative basis. The main types of client interested in this area of photography are large companies, partnerships, and organizations who want to project a particular type of public image for a specific purpose. Perhaps a company is in the process of producing its annual report for shareholders, for example. Rather than issuing dozens of bland pages of figures that mean very little to anybody without an accounting background, directors may decide to publish a glossy, magazine-style report instead. Accompanying the preamble to the accounts, you may find a brief history of the company with photographs of the company's premises and, more importantly, portraits of the key players in the company, from boardroom level down to the factory floor, with background information on them.

Another use of corporate portraiture is made by companies contemplating a stock issue, when photographically illustrated pamphlets and brochures are used to raise the public's aware-

ness of the company concerned and of those individuals who are asking to be entrusted with shareholders' money. Yet another important application for corporate portraiture is when companies commission photographic essays to accompany a quotation or bid for a major contract for work. In the fiercely competitive business climate that prevails at present, anything that makes a potential client look more favourably at one company's bid as opposed to another's could be critically important.

Corporate portraits are also used by companies to hang on the walls of the public areas of their premises, such as the reception areas, meeting rooms, and offices – in fact, anywhere clients may see them and be impressed by the image they project of the company's "way of doing business". And, finally, another outlet for company portraiture is the business press – newspapers and magazines. A well-composed, thoughtfully lit portrait could be the deciding factor in how much notice the reading public pays to a particular article.

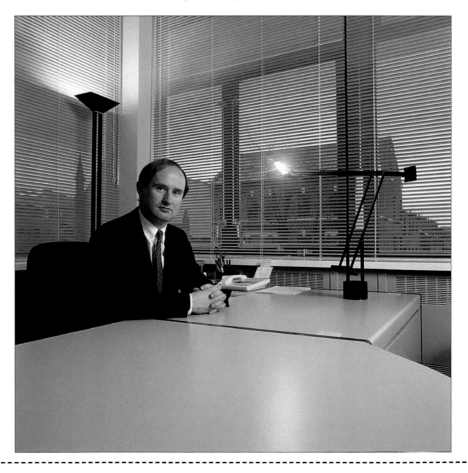

All of the elements that are central to a good portrait picture apply equally to corporate portraiture. You need to look for the best shooting angles, lighting (natural daylight or flash), background, and foreground to show your subject to best advantage.

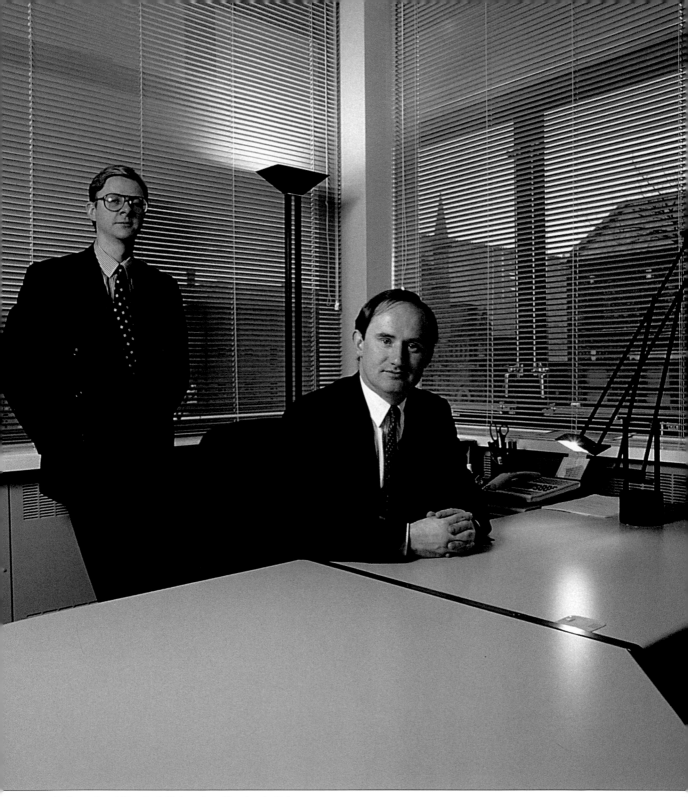

◀ ▲ *The first version of this series (left) shows the subject alone behind his desk. In order to fill the frame, the shooting angle is low and there is an expanse of featureless desk in the foreground. In the second version (above), a second subject has been included, and the desk light has also been repositioned so that the bulb is not centre frame, where it was causing a distraction. This inclusion of the second subject demanded a change in shooting position, and now the desk is less of a dominant feature.*

▲ The shooting angle is vitally important to the perceived stature of the subject. A low camera angle, looking up at the subject, makes that person seem a little larger than life. A high angle, looking down on the subject, tends to diminish that person's perceived stature.

▶ This style of corporate portrait is intended to imply the impressive nature of the client's business premises, located with a prestigious view of the River Thames in London. Daylight from the picture windows is the main source of illumination here. However, in order to relieve the contrast, the light from an accessory flash was directed at the floor in front of the subject so that a little light bounced back up into his face.

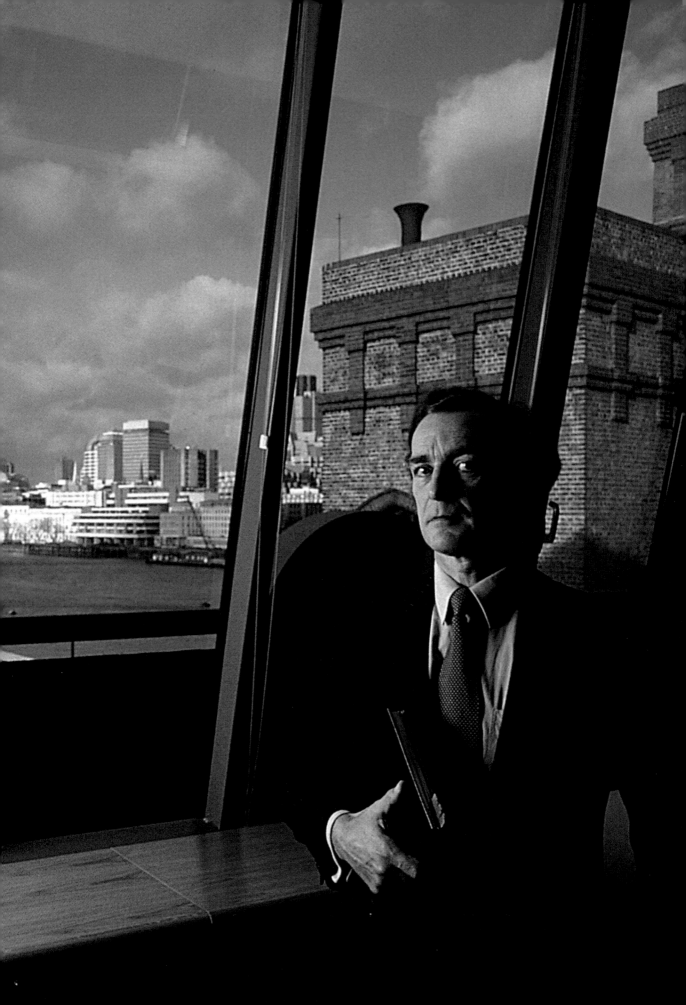

No brochure, prospectus, or annual report can be visually composed solely of corporate "mug shots", and so one of the tricks of the corporate photographer's trade is to somehow use the environment of the client's premises to add extra interest and information to the pictorial content.

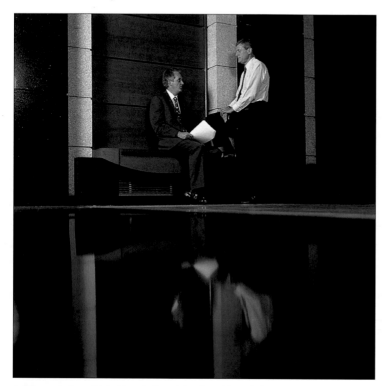

▲ *This seemingly candid double portrait was taken from this particular angle to take full advantage of the reflections cast in the indoor pool of water in the lobby area of the client's offices.*

▶ *This is a carefully composed and lit shot of a meeting taking place in the client's offices. Although it looks casual, the foreground elements of the cut-glass decanter, spectacles, printed papers, and fountain pen have been precisely arranged to add interest. The use of a wide-angle lens also adds interesting perspective distortion and helps to ensure that the depth of field is extensive enough to keep everything in sharp focus. It was important not to overpower the natural light entering the room from the rear windows, and reflecting from the framed pictures on the wall, and so heavily diffused flash was directed just at the figures to prevent them appearing as semi-silhouettes.*

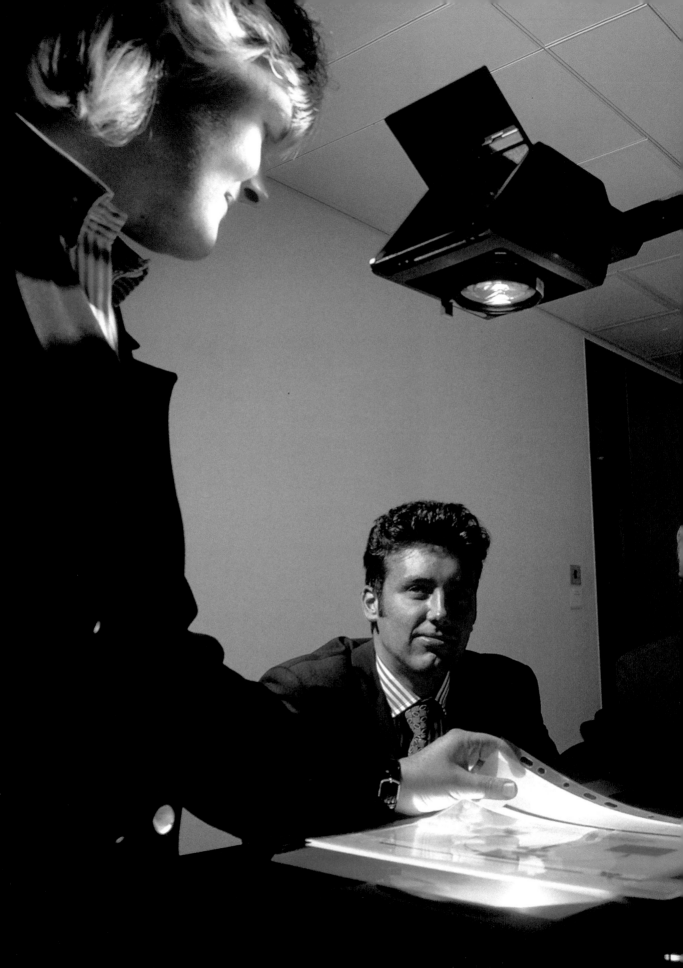

◀ Dramatic lighting and imaginative composition are the two hallmarks of this group corporate portrait. Full use has been made of the spill of light from the overhead projector onto the face of the foreground subject, while the two subjects seated in the background are framed by the column and head of the projector itself.

▲ To increase the dramatic content of this portrait, all the room lights were extinguished and the illumination coming up from the light box was the sole light used to expose the film.

If the client is involved in any form of manufacturing or testing activities, then another photographic opportunity presents itself. When you are advertising what a company has to offer a prospective client or shareholder, then the photographic coverage has to encapsulate as many aspects as possible.

▲ *The hi-tech nature of this company's activities is portrayed in this laboratory scene. The foreground has been put good effect by using the rows of test jars to direct the viewer's attention to the technician.*

▶ *Although the activity may be mundane, the angle of the shot, which is low down and uses the machine to frame the subject, and the high-contrast lighting, which has thrown the surroundings into total darkness, has real eye-catching appeal.*

▲ The framing of this double portrait, with the subjects positioned in the lower corner of the picture, has immediate impact. The unusual nature of the setting has been reinforced by angling the camera slightly to create a strongly diagonal composition.

▲ How many times have you remarked that an advertisement you have watched on television is particularly entertaining for one reason or the other, but you cannot remember the name of the product being advertised after seeing it? Sometimes the visuals can be so good that they actually get in the way of the message. The corporate portrait illustrated here neatly avoids this trap by using the company's name itself as the centrepiece of the composition. The name is not only seen against the dark wall at the rear of the room, but it is also repeated as a reflection in the highly polished table in the foreground. The light used, shining in from the extreme left of the room, performs a double duty. Not only is it the principal light source for the subject standing on the right of the frame, it also helps to define the two seated figures by rimlighting their heads and backs, thus drawing them out and away from the background.

STEVE PYKE

Steve Pyke sees himself essentially as a portrait photographer, although the physical appearance of his subjects is only one part of what he hopes to record. Through dialogue with those he photographs, he tries to establish some insight into, and gain some understanding of, the experiences that they have gone through, the things in their lives that have shaped and moulded them. The outcome of this process is that he sees the photographic images he produces more in terms of ongoing conversations, rather than merely static records of what people looked like at a particular time.

Steve first picked up a camera in 1981, and at about the same time he happened to see a photograph of a group of old men, a picture of the last survivors of the Battle of Waterloo. It was this incident that really brought home to him the potential of photography as a means of documenting a particular era through the faces of those who are an integral part of it.

Much of Steve's work, although by no means all of it, is thematic in nature. One series of photographs is exclusively on philosophers, for example, another on veterans, and uniforms were the inspiration for a third. His series entitled "Forgiveness" was photographed in Northern Ireland. All of those pictured are people who talked to him of their personal or family experiences of the horror of the troubles in that war-torn province. Steve's latest book called *Acts of Memory*, which was produced in collaboration with a writer, deals with the subject of migration, and it includes images spanning his photographic career.

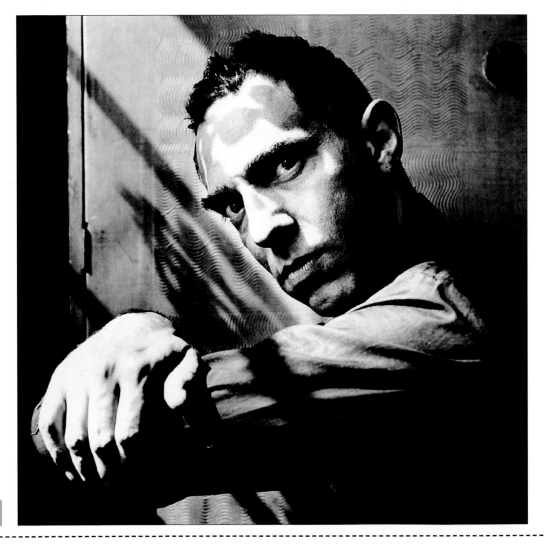

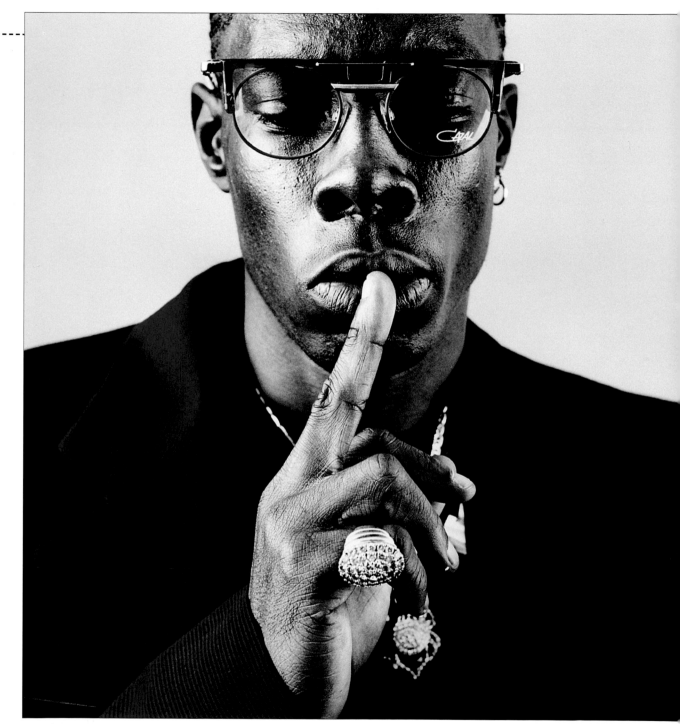

◄ Derek Jarman, 1984

This photograph of the film-maker Derek Jarman is a wide-angle portrait from early on in Steve's career. It was taken with natural window light in Jarman's home, using an aperture of f8 and a shutter speed of ⅛ second. The shadow in his forehead is cast from a potted cactus on the window sill. "Jarman was then, and always will be, a great influence on me."

▲ Shabba Ranks, 1993

For somebody who is known for being outspoken, what Steve captured in this portrait of Shabba Ranks, one of Jamaica's leading rappers, is a moment of perfect quiet. The session was in a hotel room, where Ranks arrived wearing much gold and surrounded by bodyguards, and lighting was from a studio flash and softbox. The colour effect is the result of processing slide film in colour negative chemistry.

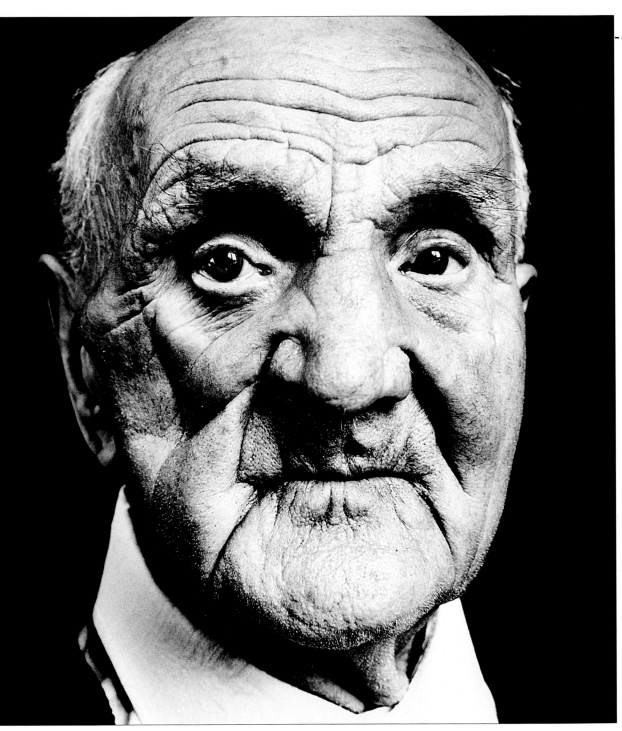

▲ *Justin Watrin, 1993*

This portrait of Justin Watrin, a World War I combatant, is part of Steve's "Veterans" series of photographs. The photograph was taken in northeast France using an aperture of f8 and a shutter speed of ⅛ second. The lighting was natural daylight. "I remember that the location was very stark and smelled strongly of disinfectant, but what impressed me most was this man's dignity and bearing."

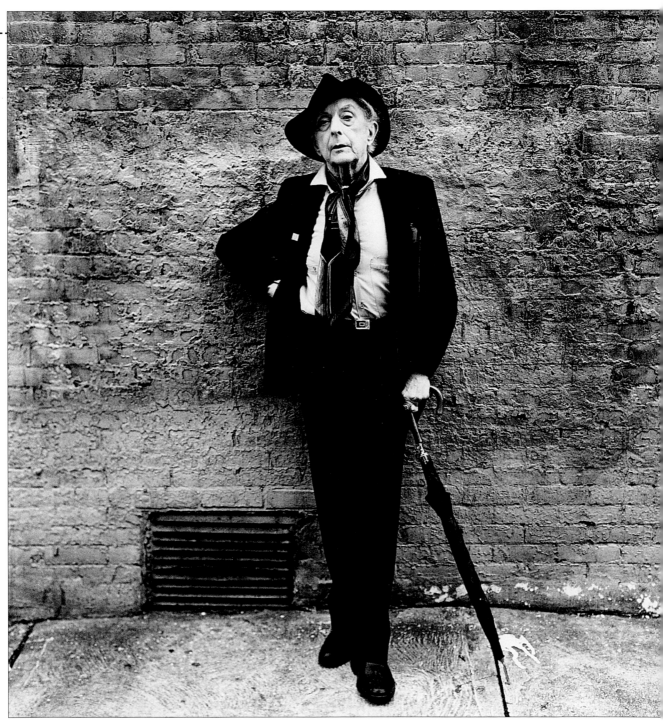

▲ *Quentin Crisp, 1993*

Steve had been wanting to meet and photograph the writer Quentin Crisp for years, and after much correspondence they finally met at his favourite diner in the Bowery area of New York. "After we'd eaten I spent an engrossing two hours as Quentin walked me around his New York." This photograph was taken on the sidewalk outside his apartment, using an aperture of f5.6 and a shutter speed of ⅟₆₀ second.

▶ **Kristin Scott-Thomas, 1992**

"I was in the process of setting up the lights for a session with my assistant when the model Kristin Scott-Thomas walked in and sat down on the edge of the bed behind me. The moment was very natural. I turned around, guessed the f stop, and shot a couple of frames. Not a word was spoken." The colour effect is the result of cross processing slide film in chemicals designed for colour negatives.

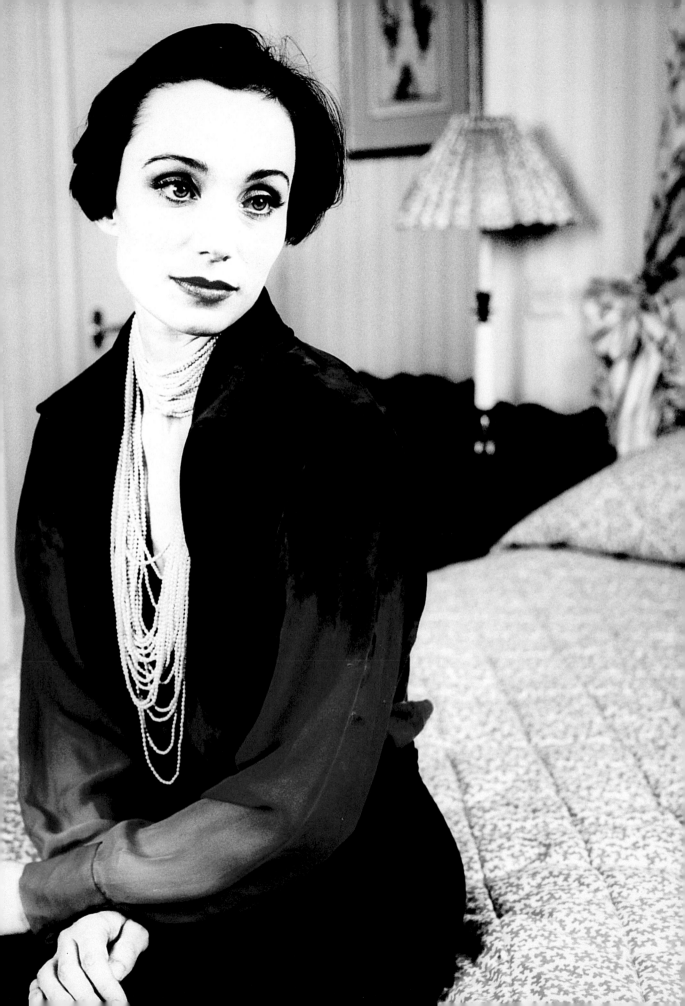

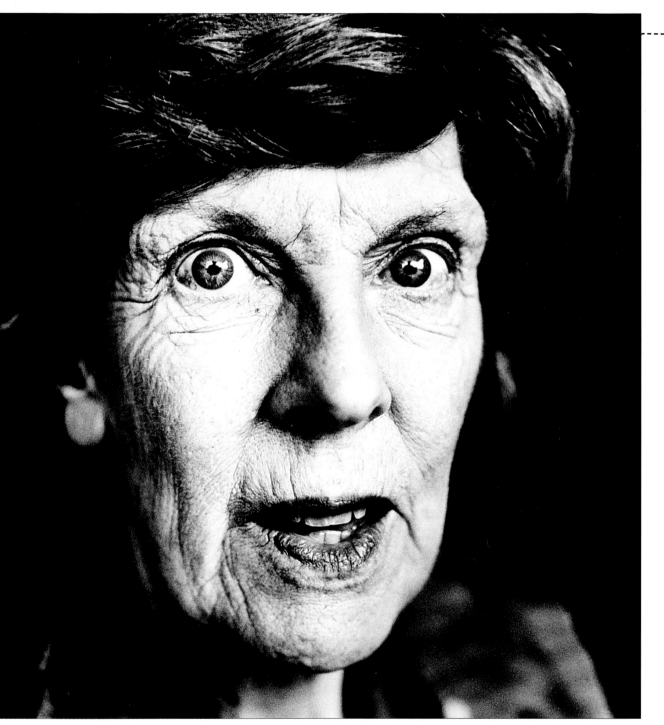

▲ *Phillipa Foot, 1990*
What immediately came across when Steve met philosopher Phillipa Foot was her vivacity. "I photographed her by natural light outside the back door of her home. I remember that at this point she was relating her wartime experiences with her friend Iris Murdoch. 'We were more scared of the advances of the American soldiers than we were of Hitler's Luftwaffe.'" An aperture of f8 and ⅛ second were used.

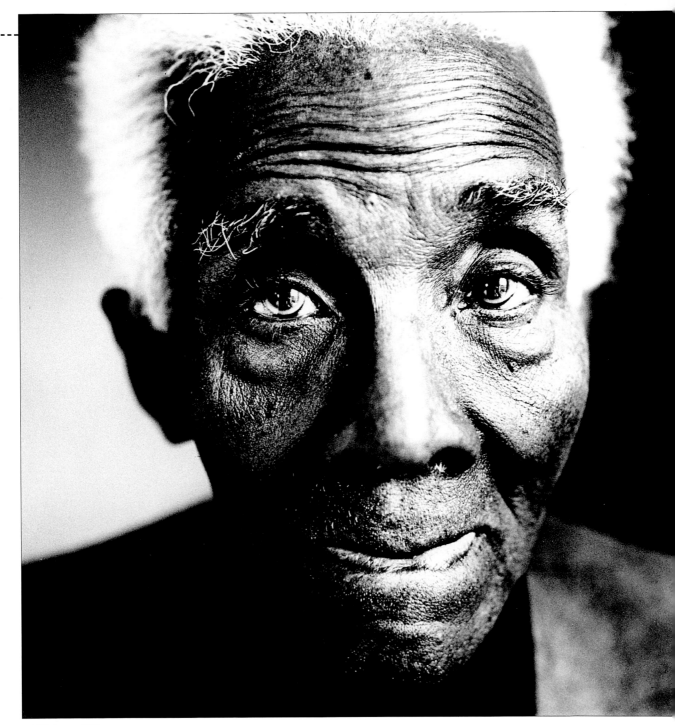

▲ CLR James, 1989

At the time Steve met and photographed the historian and political activist CLR James he was living above a bookshop in London's Brixton area. "I met him in 1989, very close to his death, and due to illness he was unable to speak. I feel this is one of my most important photographs." The lighting is natural daylight and the picture was shot at f8 using a shutter speed of ⅛ second.

DIRECTORY OF PHOTOGRAPHERS

Simon Alexander
555A Finchley Road
London NW3 7BJ
UK
Telephone: + 44 (171) 7940563
or (0956) 985710

Simon was born into a creative family in 1968. His father is an architect and his mother a writer and painter. Simon grew up in the Middle East and Singapore, but he returned to Britain in 1985 to complete his education. After finishing secondary school, he went on to art college and then drama school before eventually finishing a degree in fine arts, specializing in photographic studies, at Derby University, graduating in 1992 with a show held in both Britain and Germany. Simon moved to London in 1994 and continued his interest in editorial portraiture for such magazines as Harpers & Queen, Art Review, Livewire, Business Marketing, Big Issue, and Design Week. At present, Simon is seeking an agent to help increase his workload and heighten his exposure, particularly in the music and advertising fields.

Photograph on page 87

Richard Braine
109 Cheyne Walk
London SW10 0DJ
UK
Telephone: + 44 (0956) 288714
Fax: + 44 (171) 3520030

Born in London, and after acquiring a BSc in physics and philosophy from London University, Richard turned his creative attentions toward photography. Completely self-taught, and having been a keen amateur since the age of 15, he was the runner-up in the prestigious John Kobal Portrait Award in 1994.

Photograph on pages 42-3

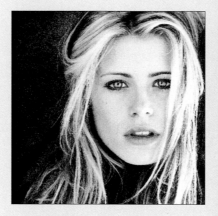

Julian Deghy
4 The Workshops
43 Carol Street
London NW1 0HT
UK
Telephone: + 44 (171) 2677635
Fax: + 44 (171) 267 8706

Photographs on pages 82, 83, 84, 85

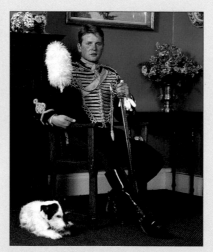

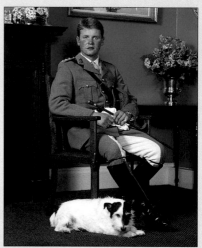

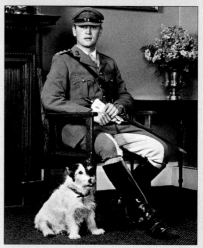

Mark Gerson
3 Regal Lane
Regents Park Road
London NW1 7TH
UK
Telephone: + 44 (171) 2865894
Fax + 44 (171) 2679246

Mark's photographic career is a long one. He first taught photography while in the RAF at the end of World War II. This was in Paris in 1946, under the auspices of the Educational and Vocational Training Scheme. He established his first portrait studio in 1947 in London's central Marble Arch area and remained in the same business all

the way thorough to 1987, although not in the same studio. Since 1987, Mark has worked as a freelance photographer. Over the years he has had numerous exhibitions, probably the best known at the National Theatre, London. The National Book League is planning a major retrospective of his work at the National Portrait Gallery in November, 1996. Mark was awarded the Fellowship of the British Institute of Professional Photographers in 1966.

Photographs on pages 28-9, 40-41

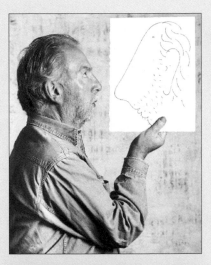

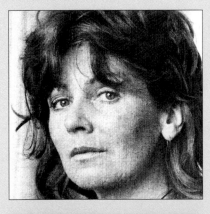

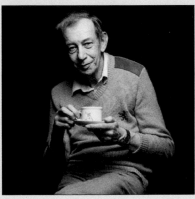

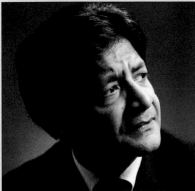

Robert Hallmann
72 Castle Road
Hadleigh
Benfleet
Essex SS7 2AT
UK
Telephone: + 44 (01702) 557404

Photographs on pages 43, 89

Nigel Harper ABIPP AMPA CrGWP
21 George Road
Stokenchurch, High Wycombe
Buckinghamshire HP14 3RN
UK
Telephone: + 44 (1494) 483434

In 1988, after pursuing several different careers without any real satisfaction, Nigel decided to take a chance and turn his long-standing hobby into a, hopefully, enjoyable profession. He enrolled in two of Fuji's one-day seminars on wedding and portrait photography, and these were enough both to inspire him and to demonstrate his natural abilities in these photographic fields. His photographic business with studio is now based at his home, where his wife takes care of the administrative details leaving

Nigel to concentrate on the photography and printing. Although his photographic career is only short, it has been punctuated by many awards: 1981 and 1982 winner of the Kodak Bride and Portrait Awards; more than 40 separate Fuji photographic awards, including 15 quarterly wins in the last two and half years; 1994 Fuji Wedding Photographer of the Year; and the Hargreaves trophy for the winning wedding portfolio in 1994. As well as running his thriving photographic business, Nigel also finds time to lecture on aspects of photography in the UK and abroad.

Photographs on pages 30-1, 32-3, 35, 68, 69, 70-1, 72-3, 110-1, 116

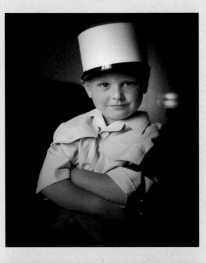

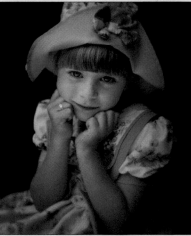

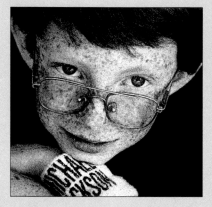

Gary Italiaander LBIPP ALCM(TD) PGCE
Harrods Portrait Studio
11 St George's Mews
London NW1 8XE
UK
Telephone: + 44 (171) 7229070
Fax: + 44 (181) 9075488

Highlights of Gary's career include: Kodak Gold Award winner; member of the Kodak Gold Circle; founder member of The Creative Portrait Circle; Chairman of The Creative Portrait Circle 1991-95; Member of the British Institute of Professional Photography; and Member of the Royal Photographic Society.

Photographs on pages 18-9, 58, 59, 60, 61, 62, 63, 64-5, 67, 114-5, 117, 124-5

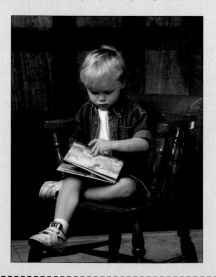

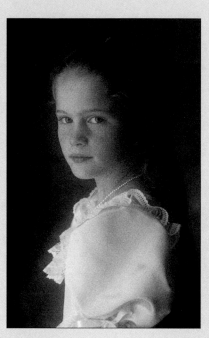

Majken Kruse LBIPP
The Coach House
East Compton
Shepton Mallet
Somerset BA4 4NR
UK
Telephone: + 44 (1749) 346901

Majken is a professional photographer with an active photographic practice specializing in weddings and portraiture. She started her working career in front of the camera as a model. At that time, photography was more of a hobby, albeit an important one. This experience, and a natural eye for photographic composition, led her to taking up photography professionally. Majken initially concentrated on children and general portraiture before widening her portfolio. She firmly believes that her experience in front of the camera helps her to relate to, and work effectively with, her subjects to achieve a natural look. Her creative talent, together with years of experience, are reflected in a very individual style.

Photographs on pages 73, 76-7, 78-9, 80, 81, 107, 108-9, 118-9

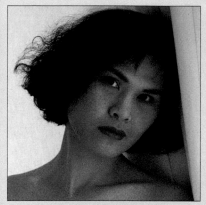

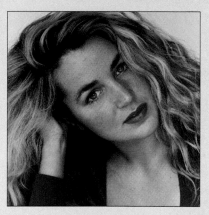

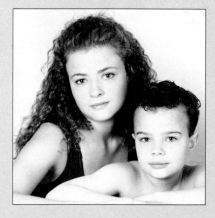

Trevor Leighton
46 Crediton Road
London NW10
UK
Telephone: + 44 (181) 9601763
Mobile: + 44 (0831) 22149

Photographs on pages 44, 46, 47

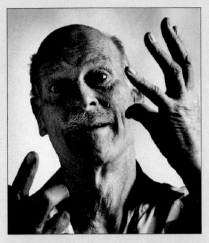

Mann and Man
Unit 9
The Dove Centre
109 Bartholomew Road
London NW5 2BJ
UK
Telephone: + 44 (171) 4280864
Fax: + 44 (171) 42808645

This unusual name is a combination of the last parts of the names of the studio's owners – Tessa Hallmann and Vikki Jackman. Tessa and Vikki first met at Bournemouth and Poole College of Art and Design and set up in partnership in February, 1992 after spending three years running the in-house photographic studio of an artwork company. Their present studio concentrates on photographing people, and most of their work is editorial or design based. They have produced scenery (set) images for the BBC's Late Show, created window-sized photographs for the department store Harvey Nichols Christmas window displays, and have created many book jackets and posters for theatres and the Royal Opera House.

Photographs on pages 123,129

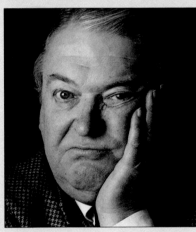

Math Maas
Brandstraat 32
6131 CT Sittard
The Netherlands
Telephone: + 31 (046) 515819
Fax: + 31 (046) 529573

Photograph on page 39

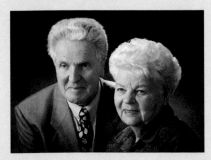

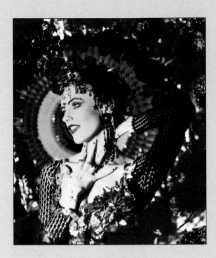

Strat Mastoris
33A Byrne Road
London SW12 9HZ
UK
Telephone: + 44 (181) 6755281
Mobile: + 44 (0802) 214725)

Photographs on pages 134, 135, 136-7, 138-9, 140-1, 142-3, 144, 145

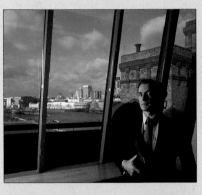

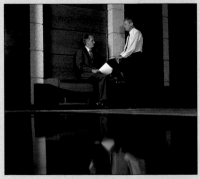

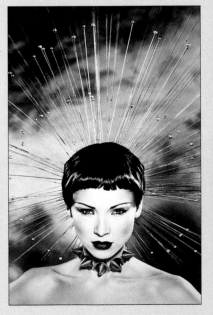

Anthony Oliver
1 Rufus Street
London N1 6PE
UK
Telephone: + 44 (171) 6134001
Fax: + 44 (171) 7297673

Photographs on pages 21, 27, 45, 54, 55, 56, 57, 98-9

Steve Pyke
West Hill Villa
Coburg Place
Old Town
Hastings
East Sussex TN34 3HY
UK
Telephone: + 44 (01424) 437702
Fax: + 44 (01424) 437716

Photographs on pages 91, 100, 102, 103, 127, 146, 147, 148, 149, 150-1, 152, 153

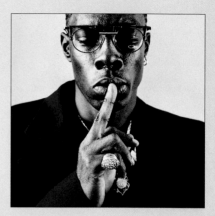

Nicholas Sinclair
c/o Jo Clark
13 Prowse Place
London NW1 9PN
UK
Telephone: + 44 (171) 2677267
Fax: + 44 (171) 2677495

Although born in London, Nicholas Sinclair studied fine art at the University of Newcastle-upon-Tyne between 1973 and 1976. Since leaving university, his photographic work has been widely exhibited and published in Britain, mainland Europe, and in the United States of America. Nicholas's work is now represented in the permanent collection of the National Portrait Gallery, London.

Photographs on pages 34, 93, 94-5

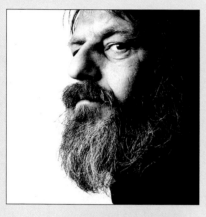

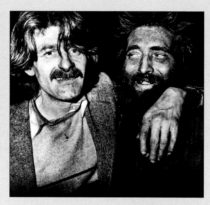

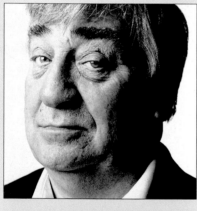

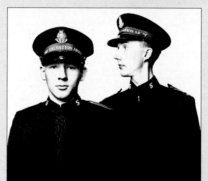

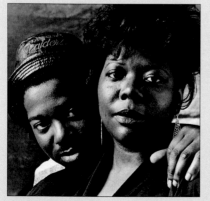

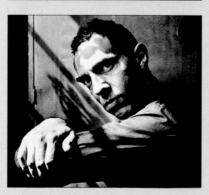

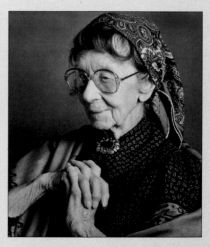

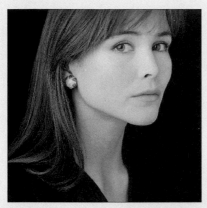

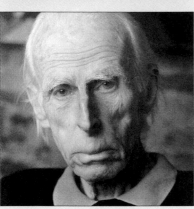

and 1993, where she held two exhibitions of her work. She also taught photography in France while working for a theme holiday company. As well as exhibiting regularly at Hays Gallery in Deptford, London, Linda is also the winner of numerous photographic competition awards.

Photograph on page 75

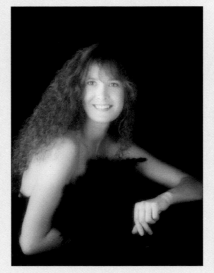

1992 and 1993. As well as running his business as a professional photographer, Jos has also been invited to lecture not only in his native Holland, but also in Belgium, Germany, England, Scotland, Norway, and Cyprus.

Photographs on pages 16, 22, 23, 24-5, 36, 37, 38-9, 50-1, 52, 53, 104, 105, 113, 131

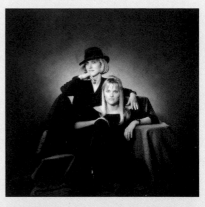

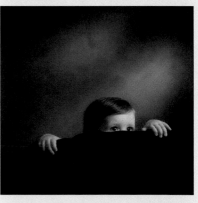

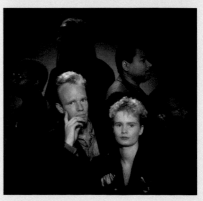

Linda Sole
33 Coleraine Road
London SE3 7PF
UK
Telephone: + 44 (181) 8588954
Fax: + 44 (171) 7398840

Born in 1943 in Ireland's County Durham, Linda Sole now lives and works in southeast London earning her living as a freelance photographer concentrating principally on reportage and photo-documentary. Linda joined the Independent Photographers' Project in 1983, organizing workshops and photographic local events. Teaching photography has been a strand running through Linda's career, and she has taught and lectured on photography at various schools and colleges in Britain and abroad. She was also resident photographer at Blackheath Concert Halls between 1991

Jos Sprangers FBIPP
Dorpstraat 74-76
4851 CN Ulvenhout
The Netherlands
Telephone: + 31 (76) 613207
Fax: + 31 (76) 601844

As well as being a Fellow of the British Institute of Professional Photography, Jos is also a qualified member of the Dutch Institute of Professional Photography. In 1970 Jos started his own business, combining photographic retailing with general photographic work. By 1980, however, he abandoned the retailing side completely to concentrate solely on undertaking commissioned photography. He is a three-time winner of the Camera d'Or. Throughout the years Jos has won many prestigious competitions, culminating in being judged Brides Photographer of the Year (England) in both

ACKNOWLEDGEMENTS

In large part, the production of this book was made possible only by the generosity of many of the portrait photographers who permitted their work to be published free of charge, and the publishers would like to acknowledge their most valuable contribution. Similarly, the publishers would also like to thank all the subjects who appear in the photographs included in this book.

The publishers would also like to thank the following individuals and organizations for their professional and technical assistance and services, in particular Keith Patrick of *Art Line Magazine*, Koen de Witte of Photoart, for organizing the contribution of the Dutch and Belgium photographers, Jos Sprangers, E.T. Archive, and the equipment manufacturers whose cameras, lenses, flash units, and other lighting equipment appear at the beginning of the book, especially to the importers of Hasselblad (UK) Limited and of Multiblitz.

All of the illustrations in this book were drawn by Madeleine Hardie and Michael Hill.

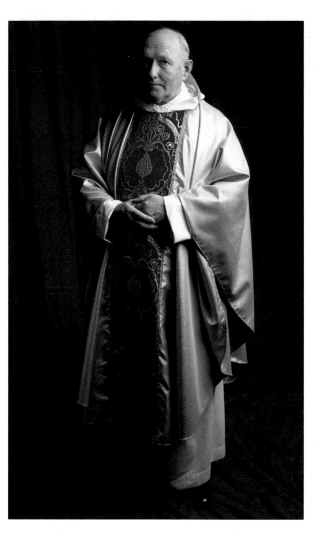